MICHAEL FREEMAN'S
PHOTO SCHOOL
BLACK & WHITE

MICHAEL FREEMAN'S PHOTO SCHOOL
BLACK & WHITE

EDITOR-IN-CHIEF **MICHAEL FREEMAN**
WITH **STEVE LUCK**

ILEX

First published in the UK in 2012 by

I L E X

210 High Street
Lewes
East Sussex BN7 2NS
www.ilex-press.com

Publisher: Alastair Campbell
Associate Publisher: Adam Juniper
Creative Director: James Hollywell
Managing Editor: Natalia Price-Cabrera
Specialist Editor: Frank Gallaugher
Editor: Tara Gallagher
Senior Designer: Ginny Zeal
Designer: Lisa McCormick
Colour Origination: Ivy Press Reprographics

British Library Cataloguing-in-Publication Data
A catalogue record for this book is available
from the British Library

ISBN: 978-1-908150-97-4

Printed and bound in China

10 9 8 7 6 5 4 3 2 1

Photo on page 2 © Photocreo
Photo on page 4 © Steve Luck
All other photography © Michael Freeman
unless otherwise indicated.

Contents

FOREWORD

About This Series

Photography is what I do and have done for most of my life, and like any professional, I work at it, trying to improve my skills and my ideas. I actually enjoy sharing all of this, because I love photography and want as many people as possible to do it—but do it well. This includes learning why good photographs work and where they fit in the history of the craft.

This series of books is inspired by the structure of a college course, and of the benefits of a collective learning environment. Here, we're setting out to teach the fundamentals of photography in a foundational course, before moving on to teach specialist areas—much as a student would study a set first-year course before moving on to studying elective subjects of their own choosing.

The goal of these books is not only to instruct and educate, but also to motivate and inspire. Toward that end, many of the topics will be punctuated by a challenge to get out and shoot under a specific scenario, demonstrating and practicing the skills that were covered in the preceding sections. Further, we feature the work of several real-life photography students as they respond to these challenges themselves. As they discuss and I review their work, we hope to make the material all the more approachable and achievable.

For you, the reader, this series provides, I hope, a thorough education in photography, not just allowing you to shoot better pictures, but also to gain the same in-depth knowledge that degree students and professionals do, and all achieved through exercises that are at the same time fun and educational. That is why we've also built a website for this series, to which I encourage you to post your responses to the shooting challenges for feedback from your peers. You'll find the website at **www.mfphotoschool.com**

Student Profiles

Josh Ryken

Josh received his first camera at age five—a little Fischer-Price children's camera. While his gear didn't improve for the next 13 years, he has always been in love with photography, and with the permanence of the photographic medium. Since buying a Nikon D5100 in 2011, he's been making up for lost time. His camera goes everywhere with him. Although he dabbles in portraiture and other "intentional" photography, he primarily take pictures of things he sees and places he goes. He is motivated to preserve memories in a permanent way that others can enjoy. More than that, photography allows him to interact with the world in a deeper way; instead of being merely an observer, he becomes a narrator, providing a permanent interpretation of the world.

So far, the internet has been his only photography teacher. He voraciously reads photography blogs and forums, looking for new techniques and ideas to can incorporate into his own work. The internet also taught him Photoshop and Lightroom, and how post-processing ought to look. Hardly a day goes by when he doesn't turn to the internet for photography help.

Currently Josh is an undergraduate at Wheaton College in Wheaton, Illinois, USA. He doesn't have plans to pursue photography professionally—it's just a fun hobby. Other hobbies include reading, filmmaking, audio engineering, and playing sports.

More of Josh's work is available at: http://www.flickr.com/photos/jryken

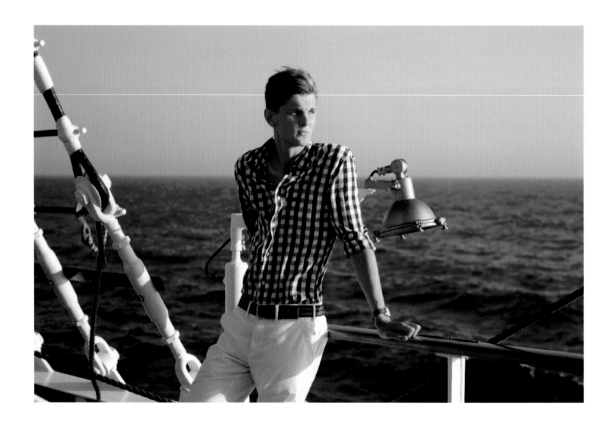

Benoît Auguste

What started as a casual hobby of documenting events has become a creative passion and a driving force in Benoît's life. For some time he worked in an office, but it didn't take long for him to realize he's much more cut out for roaming city streets and capturing decisive moments as they reveal themselves. So he left the office job, got a Nikon D300s, and has been working toward being a Paris-based professional photojournalist ever since.

Benoît is an autodidact, having taught himself by rigorous experimentation and exhaustive studies of great photographers. He is strongly influenced by William Klein, Robert Frank, Diane Arbus, JH Lartigue, and—of course—HCB (Henri Cartier-Bresson).

He has lived in Paris since age 18, and this magnificent city never ceases to amaze and inspire him. He chooses to photograph mostly in black and white because that is how he remembers his surroundings—the sky is gray, the walls and buildings are gray, the people don't wear bright colors, even the river Seine is more gray than blue. It also doesn't hurt that in his latest work, he photographs mostly at night, as this is when some of the most important action happens. Daylight, he feels, often reveals too much and can make it difficult to isolate the smaller, more significant dramas; whereas the night and low-light atmospheres help cut straight to what is most essential.

To explore more of Benoît's work, visit: http://cargocollective.com/olybrius and http://www.facebook.com/olybrius.fr

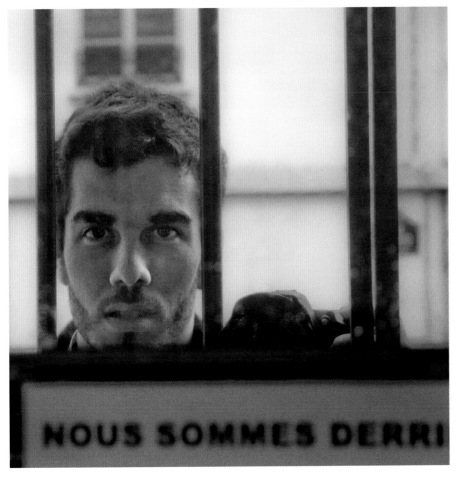

NOUS SOMMES DERRI

Dan Goetsch

Dan Goetsch was born and raised in Fort Collins, Colorado. He eventually ended up hitting the ground running in the IT world just after college and life has been an adventure ever since. Through his work, Dan has had the opportunity to do a good amount of travel, which led him to relocate to the west coast. He found his new home in Portland, Oregon where he spent 5 years, and picked up his first digital SLR camera along with a passion for photography. He is a self-taught photographer who has gone from Auto mode to Manual and enjoyed every minute of the journey as he continues to learn and explore the craft. His superhero mantra would be "IT nerd by day, photographer by nights and weekends."

After living in the Pacific Northwest for a while, he eventually grew homesick and took an opportunity to relocate back to Colorado where he currently resides. He always looks for an opportunity to learn something new about the trade, and is always looking for a challenge.

Dan's passion for photography continues to grow stronger every day, and he looks forward to sharing his love of it with the world.

You can see his work at www.danielgphotography.com

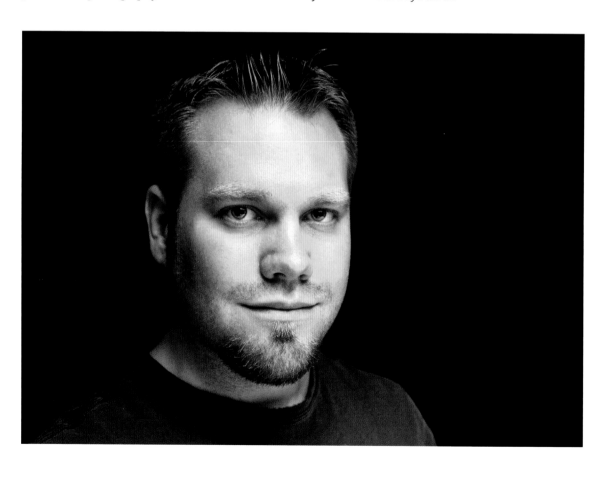

Kryštof Kalina

From the Czech Republic and currently based in Prague, Kryštof has been a freelance photographer for about four years, and his main focuses are concert photography, reportage, portrait, and fashion.

He studied photography for two years at Miroslav Vojtěchovský and Marian Beneš' atelier, and graduated from Prague Film School where he got acquainted with cinematography and directing. He has participated in several group exhibitions, including the Prague Biennale, Prague Quadriennale, and Designblok.

His main sources of inspiration are poetry, philosophy, movie-like aesthetics, early photography reportage, glitch culture, rock and roll, and jazz. While he still feels flexible about his style and signature, his impulses for photography are clear: follow a passion to visually communicate, capture the moment, recreate an experience, or simply "paint with light."

To have a peak into his world visit: www.krstf.com

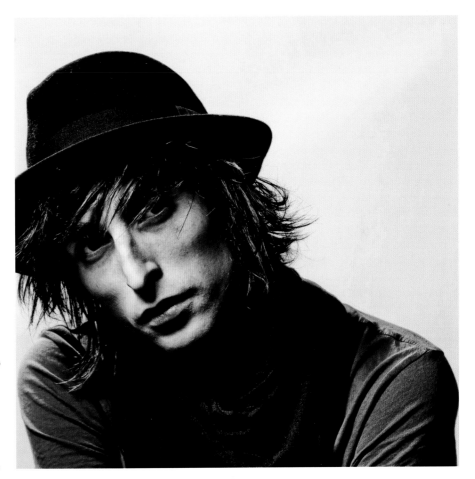

Introduction

Black-and-white photography occupies a unique place in the world of art and imaging, all the more surprising because within the world of photography it is taken so much for granted. While we are now capable of simply clicking an Auto button and converting our color images to black and white in a split second, the vast array of creative tools at our disposal that you will discover throughout this book will soon make such automation seem entirely insufficient.

More than a simple overview of the current software and techniques, however, this book is also a training course in understanding the aesthetics of black and white—recognizing the role it plays in the interpretation of a scene, its usefulness for bringing out graphic elements or evoking a particular mood, and its ability to transform not just the appearance, but also the meaning, of an image. Pairing this thematic understanding of what black-and-white photography means with a familiarity with today's software conversion tools is key to getting started in black and white, as you will avoid wandering in the dark—pushing sliders this way and that with no clear direction or intention—and instead have a clear vision (or several visions) for your final output, and the knowledge to achieve that output efficiently and competently.

Digital photography has very clearly changed the way we can shoot in black and white, and it is perfectly obvious that by far the most important practical difference between a sensor and film is that now you can have both color and monochrome from the same shot. There is no prior choice to be made, no decision to load black-and-white film rather than color film before setting out. As a result, most of what is written and discussed about digital black and white focuses on the practicalities—how to convert, how to adjust channels in order to alter the brightness of different colors as they appear in grayscale, how to achieve the "look" and grain of a favored black-and-white emulsion, and so on. All essential and all valuable topics to study, but all skipping the one key issue: More fundamental than the "how" of shooting monochrome is why and when. There's nothing too complicated about explaining how to achieve all the

← Subtle shades
Contrary to its literal name, black-and-white photography is mostly about what falls in between those tonal extremes. Certainly, high-contrast black and white has an edgy quality to it, but some of the finest work is done with excruciatingly nuanced differentiation of shades that come together to portray a given subject.

various kinds of monochrome effect from a digital image, but much more interesting is the choice to make the image in black-and-white rather than in the more obvious color.

This choice draws us into the long and rich tradition of black-and-white photography—traditionally more strongly associated with art than is color, and there are lessons to learn also from monochrome painting. The common theme running through all of this is restricting the palette. What sets black and white apart from color is that it is not the way we see the world and it does not pretend to represent reality. It is a translation of a view into a special medium with very particular characteristics. As we will see, there has been a changing perception of black and white as a medium in photography. Crudely put, it began as necessity, then became accepted as normal, and now, with the full choice of color (and any kind of color) coupled with the infinite processing possibilities of digital images, it is a creative choice.

→ **Reach for the graphics**
By stripping out the color information from a scene, it becomes much easier to isolate the shape and form rather than the literal subject matter.

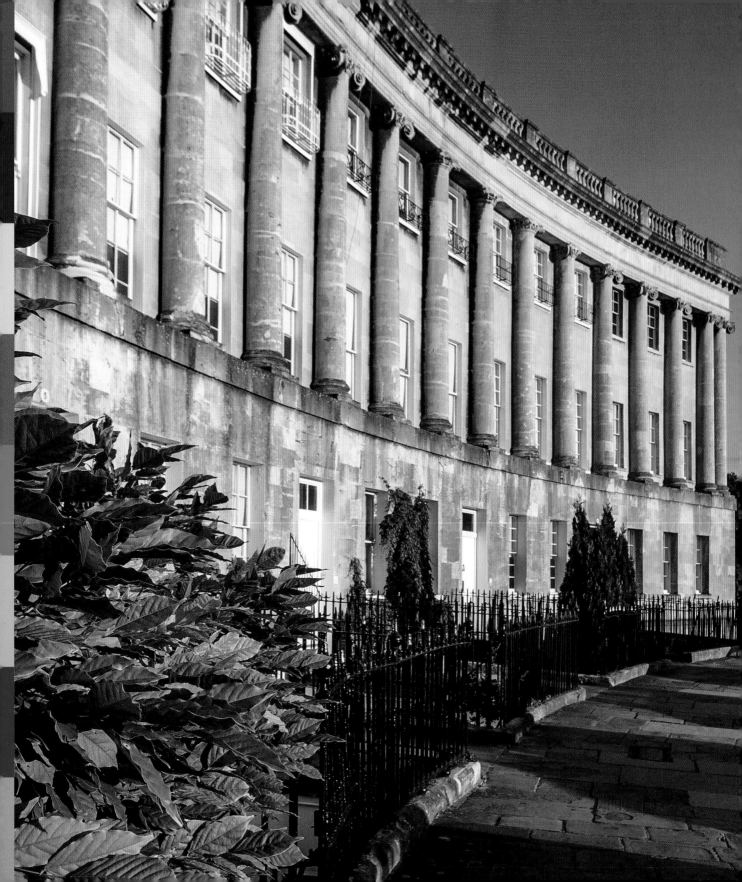

Converting from Color

A digital camera's sensor can only record tonal values; in other words they are monochrome devices. However, almost all cameras feature some form of color filter that sits over the sensor and which disassembles the millions of real-world colors into the three additive primary colors—red, green, and blue. And by recombining combinations of red, green, and blue light, we can reproduce the millions of colors we see around us.

This information is key to how we go about converting color images to black and white using imaging software. Having the ability to access and adjust the residual red, green, and blue channels of a newly converted monochrome image allows us to adjust the brightness values of elements of an image associated with those hues. And today's imaging software goes even further, allowing us to target six or even eight key hues. This gives us unparalleled creative control over how we want our black-and-white images to look. We can darken skies, lighten foliage, separate tones, and emphasize dominant colors, all by manipulating color sliders.

Colors Become Tones

Although there are numerous ways to convert a digital color image into black and white, they all involve removing or filtering out hue or color at some stage, resulting in a grayscale image made up of black and white and the many variations of gray tones in between.

The success of grayscale conversion centers around two things—technical knowledge and a sympathetic eye. The first is relatively straightforward to master—and we'll show you a number of popular black-and-white conversion techniques, during the course of the book, that provide you with the means to manually adjust and fine-tune how colors are converted. The second, being subjective, is perhaps harder to learn. On one level, it involves having the ability to look at a color image and seeing how best those colors translate into black and white tones so that the monochrome image remains "true" to the color version. As we shall go on to discover, even though our visual experience is essentially a color one, we still have expectations of how those colors should be rendered when converted to grayscale.

Yet, on another level, there are a great many creative possibilities open to us when performing a black-and-white conversion that stray away from a monochrome "reality," such as high-key and low-key approaches, both of which use extremes of tone to create a specific response from the viewer. These subjective creative possibilities are explored more fully in The Black & White Tradition (see pages 46–77).

In-camera Black and White

A word of warning before proceeding any further: Avoid the temptation to use your camera's B&W setting if you're shooting only JPEGs. With this setting active, the camera decides on the spot how the colors should be converted and removes all the color information when the image is saved as a JPEG. The result is that you won't have the ability to alter or amend the RGB grayscale blends later in image-editing software should you want to create your own specific grayscale interpretation.

RGB Color

An appreciation of the practical approaches to black-and-white conversion is perhaps more fully realized if we at first understand how an RGB color image is created. A digital camera's sensor can only record luminance or brightness values, it cannot record color. Without any further intervention, therefore, the sensor from a digital camera could only record grayscale images. The color is generated by a grid-like filter made up of red, green, and blue components that overlies the sensor. Most filters follow what is called the Bayer pattern, in which there are twice as many green elements as there are red and blue. This is to ensure that the filter mirrors human vision, which is twice as sensitive to the yellow-green wavelengths.

Color images therefore are made up of three discrete red, green, and blue (RGB) grayscale channels, which when combined create a full-color image; and as we shall discover later, it's the adjustment and blending together of these three grayscale channels that lies at the heart of some of the most versatile monochrome conversion techniques.

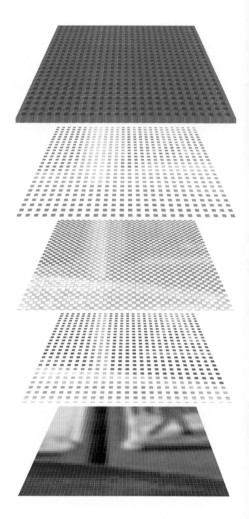

↑ Full color in three parts

A digital color image is made up of red, green, and blue pixels. In imaging software these components can be represented by three grayscale channels.

Red channel

Green channel

Blue channel

The Tones We Expect

© Steve Luck

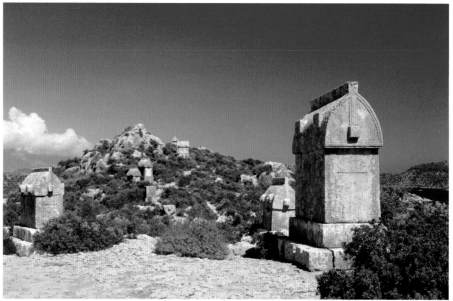

Unlike a color image, for which we have real-world reference, the black-and-white image in the age of digital photography inhabits a near limitless world of tonal possibilities—and therefore by extension potentially endless creative interpretations. However, there are still some innate visual rules to follow.

Just as the issue of color management has become a significant (and often hard-to-decipher) aspect of digital photography—simply because nowadays it's possible through the use of versatile adjustment tools to "get color right"—the same is also true of black-and-white imagery; it's now possible to convert the individual colors in a color image into just about any tone of gray you wish using adjustment tools that are just as versatile.

However, unlike with color imagery, in which we can utilize universally recognized color charts and color profiles to ensure a consistent and "accurate" treatment, when converting to black and white we have only our own inherent sense of what looks right to go by. Yellows should appear bright, for example, while blues and purples should be darker; but it's certainly not a precise science—there are no universally recognized grayscale "values" for the different colors. We cannot apply a scale of "brightness"

↑←↓ Ancient necropolis at Simena
Today's powerful black-and-white conversion tools allow us to easily create a variety of monochrome interpretations of the same scene.

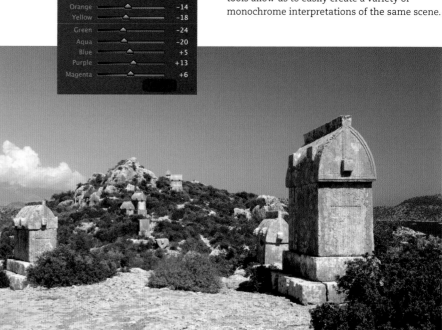

Black & White Mix	
Red	−5
Orange	−14
Yellow	−18
Green	−24
Aqua	−20
Blue	+5
Purple	+13
Magenta	+6

→↗ Straightforward conversion
The Auto settings here have provided a monochrome version close to what our eyes would expect to see. The grayscale tones appear to be accurate representations of the color present in the image.

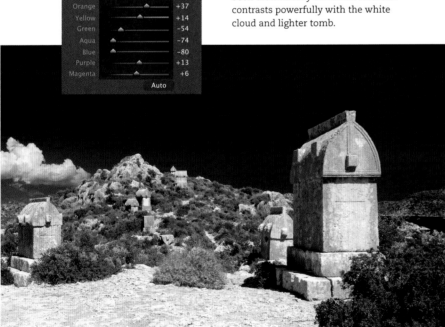

←↓ Brighter, but lacking contrast
In this version the sky is much lighter and the tomb and foreground darker emphasizing the texture of both.

←↓ A definitive interpretation
In this final rendition, the sky has been dramatically darkened and now contrasts powerfully with the white cloud and lighter tomb.

that shadows each color's unique wavelength in the visible spectrum. Take red and blue as an example: If we applied a grayscale version based on wavelength this would result in either red or blue (which are close to opposite ends of the visible spectrum) being rendered as either very light or very dark gray—or the other way around. However, this often isn't the case. In some basic conversion routines converting blue and red to grays will produce a similar-looking tone.

The closest thing we have to a set of grayscale values was proposed by the German poet and scientist Johann Wolfgang von Goethe in his book *Theory of Colors*. He gave relative values, ranging from bright to dark, of yellow 9, orange 8, red and green 6, blue 4, and violet 3. However, Goethe makes it clear that his theory is based not on a systematic analysis of light but rather on experience and perception.

Therefore, without some form of grayscale measuring device, we're back to relying on our expectations of how colors are rendered as plain tones when performing black-and-white conversions. But we should not see this as a setback in the quest for objective grayscale accuracy. Instead, combined with the versatility of modern conversion techniques, the lack of a measurable scale of gray allows us to experiment with tone for creative impact. Take, for example, an image that has strong contrasting colors, with today's conversion techniques it's possible to create two entirely different black-and-white interpretations.

The Software Tools

The ability to convert a color image into monochrome using editing software has always been with us, but has grown increasingly sophisticated over time. However, the original methods are still available should you wish to use them.

Grayscale

One of the easiest and quickest ways to convert a color image to black and white is to use the Grayscale menu option. In most cases the software utilizes around 60% of the green channel value, 30% of the red, and 10% of the blue. These values are based on how the human eye responds to color.

Although quick and easy, and capable of producing acceptable results, this option deletes all the color information from the image file, and so offers zero level of control.

Desaturate

Desaturate is another "one-stop" method, but unlike the Grayscale option, Desaturate takes equal values from each of the color channels. The same result is obtained by setting Saturation to zero in the Hue/Saturation dialog box.

Channel Mixer

For full creative control when converting to monochrome you need to be able to access the image's color channel information. Such access allows you to fine-tune the conversion so that it's possible to effectively separate the colors into appropriate and discrete gray tones.

For some years the Channel Mixer was the tool of choice for black-and-white conversion—and it's still popular today. The Channel Mixer dialog comprises three sliders—Red, Green, and Blue—which correspond to the RGB color channels, and usually a Monochrome check box. For black-and-white conversion click the Monochrome check box and adjust the sliders until you are happy with the black-and-white output. Try to keep the overall value to 100%.

↘→ Preserving the original data
Using a Channel Mixer adjustment layer preserves the color in the original image so you can revise the settings at any time in multilayered images.

© Steve Luck

↑ Channel mixer as a digital filter set
For many, particularly those who may have used colored filters when shooting black-and-white film, using the Channel Mixer is an intuitive way of getting a black-and-white conversion with good contrast and tonal separation.

Channel Mixer		
Preset: Custom ⬍		OK
Output Channel: Gray ⬍		Reset
Source Channels		☑ Preview
Red:	50 %	
Green:	50 %	
Blue:	0 %	
Total:	+100%	
Constant:	0 %	
☑ Monochrome		

Black and White

The most powerful and versatile monochrome conversion command found in many editing packages, in both post-production software and some Raw convertors, is the Black & White panel.

The Black & White panel can be thought of as an extension of the Channel Mixer, but instead of targeting just the red, green, and blue channels, you have access to a greater, more specific range of colors. In the case of Photoshop, for example, you can adjust both additive and subtractive primary colors, so cyan, magenta, and yellow, as well as the red, green, and blue additives; while with Adobe Camera Raw (ACR) and Lightroom you have sliders for eight "real-world" colors—red, orange, yellow, green, aqua, blue, purple, and magenta.

Naturally, the ability to explore and adjust the equivalent grayscale tonal values of so many colors provides for an exceptional level of control; but perhaps an even more powerful aspect of both Photoshop's and Lightroom's black-and-white conversion tool is the targeted adjustment tool. In both cases drag the tool over a selected area and the program will lighten or darken all the color tones associated with that specific region of the image, depending on the movement of the cursor. As you do so you'll notice how the relevant sliders move as you make the adjustment. This, in effect, allows you to create a monochrome conversion using an intuitive painting action that adjusts all the relevant color tones at the same time, rather than by having to use individual sliders.

© Steve Luck

↑↗ Target only specific areas of the frame
The targeted adjustment tool (shown here circled) is enabled by clicking the icon in the Black & White panel. The tool represents an intuitive way of fine-tuning monochrome conversion using movements of the mouse or pen and tablet.

Nik Silver Efex Pro

A powerful alternative to the Channel Mixer and Black & White panels is Nik's Silver Efex Pro software. Available as both a standalone program or as a Photoshop or Lightroom plugin, Silver Efex Pro is a feature-rich program dedicated to black-and-white conversion. Highlights of the program are Nik's unique U Point Technology, (which permits powerful localized adjustment), good ranges of both monochrome preset styles and black-and-white film emulation, and a host of toning options. The program has an attractive and intuitive interface, and although ultimately you can achieve similar results using standard editing software, Silver Efex Pro encourages experimentation and can speed up workflow.

↓ Mimicking film
A subpanel allows you to fine-tune the grain, contrast, and texture of any preset to emulate those qualities in many classic film types.

Basic Optimization

No matter what tools you use to perform a black-and-white conversion, it's important that you set some basic parameters before fine-tuning the image. The purpose of the processes outlined here, which can be applied using either a Raw converter or post-production software, is to ensure that the image is fully optimized, so bringing out the three key qualities of black-and-white imagery—namely tonal range, brightness, and contrast.

Tonal Range

The first step is to ensure the image contains the complete range of tones from white to black—this is the mainstay of optimization. How you achieve this will depend on the software you're working with. In Raw-conversion software, before converting to black and white, work through the basic sliders, such as Exposure, Highlights, and Shadows, or Recovery to ensure the highlights and (less importantly) the shadows are set at their optimum points. The intention is to fill the entire width of the histogram. If you're working on an already processed TIFF using post-production software such as Photoshop or Paint Shop Pro, for example, use the Levels command to set the black (shadow) and white (highlight) points.

As well as having a histogram to guide you, most software will feature some form of clipping warning that shows you at what point the black and white tones are clipping. Enable the clipping warning and adjust the image until

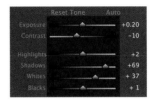

↑→ Start at the top

Although the specific tools and methodology may vary depending on the particular Raw converter you choose, start the optimization process by maximizing the tonal range of the image. Use the highlight and shadow warning option (shown here in red and blue respectively) to indicate the point at which each end of the histogram is getting clipped. There may be a key option that shows a clipping preview screen.

↘→→ Work in Levels

To set the black and white points in a processed TIFF, call up the Levels command and drag the black-point slider to align with the left of the histogram. Repeat the same process with the white-point slider, but be careful not to clip any highlight detail. In Photoshop, holding down the Option/Alt key provides a preview of the clipped areas.

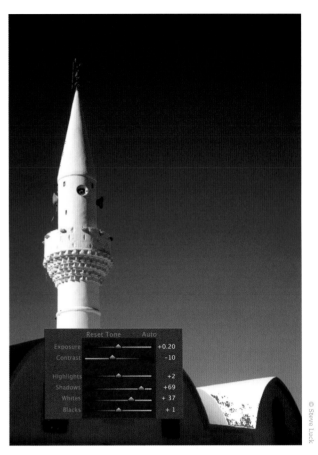

© Steve Luck

Black clipping point White clipping point

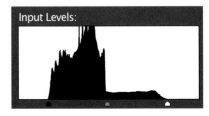

you're satisfied that the highlights and shadows are accurately set.

When setting the white point it's important to make the distinction between specular and nonspecular highlights. Examples of specular highlights include the reflection of sunlight off water or the shiny surface of a car. Specular highlights don't contain any detail and ideally should be clipped—if not the final result may look flat. Nonspecular, or nonreflective, highlights on the other hand, are the brightest parts of the image that retain detail, and should definitely not be clipped—otherwise you'll lose important highlight detail.

Brightness

While tonal range is, to a certain extent, measurable and determined by setting the black and white points, brightness is far more subjective and should be set according to what complements the image and to the photographer's individual taste. For these reasons, it's usually prudent to finalize brightness once the image is in its monochromatic state.

Again, how you adjust overall brightness levels depends on your particular software, but a Curves adjustment layer in post-production software offers a good level of control without affecting the black or white points. While for those using a Raw editor, the Brightness slider (or if that is not available—the Exposure slider) is the traditional route, using additional controls if necessary to ensure highlights (or shadows) don't clip.

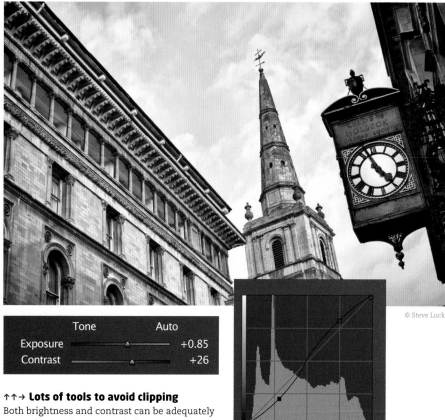

© Steve Luck

Tone		Auto
Exposure		+0.85
Contrast		+26

↑↑→ **Lots of tools to avoid clipping**
Both brightness and contrast can be adequately covered using the same tools in most Raw converters and post-production image editors. In the case of the former, the Exposure and Contrast (or Brightness) sliders are effective at adjusting the mid-tones, but can force the highlights to clip. So turn to other sliders such as Highlights or Recovery to bring them back. In post-production software the Curves command provides a powerful yet versatile means of setting both brightness and global contrast. Of course, for more local adjustment make a selection of the area and tweak the exposure accordingly.

Contrast

Finally, assess the image for contrast. Essentially, contrast is the relationship between the brightest and darkest tones; however, it is generally accepted that you exclude the very brightest (specular) and very darkest tones, as taking these into account will usually give an extreme result.

With the sophisticated algorithms found in today's software, it's possible to make localized contrast adjustment in which adjustments are made depending on the value of neighboring pixels (e.g., Lightroom's Clarity slider). This additional level of control, while providing the opportunity to add extra punch to an image, can easily look unrealistic if used injudiciously.

Although the optimization processes described here appear to follow a set workflow, they are to some degree interdependent on one another. So do bear in mind that having made one adjustment, it may be necessary to return to a previous process to address any changes that may have occurred.

Challenge

Create Your Own Workflow

While each image deserves a certain degree of its own attention, it's important to be efficient in your workflow and tailor it to your own particular visual and shooting style. Toward that end, pick a batch of photos of a common subject or theme that you want to convert into black and white, and develop an optimal workflow that lets your make the big, broad changes quickly and easily, so you can concentrate on the more delicate adjustments with a keener eye. It's all well and good to spend hours and hours in the digital darkroom, and indeed that can be very enjoyable; but speed and efficiency are part of the professional photographic life, and when a client is waiting on delivery, it's essential that you have a steady routine for importing, sorting, organizing, prioritizing, and fine-tuning your images to make sure you meet your deadline. Exactly how you do this will depend on the software you use, but here is just one way you could consider working.

→ **Begin with organization**
While your particular workflow may well be unique, it should invariably begin with some manner of sorting and organization. Here I've used Adobe Bridge to tag three tiers of images: Red is unlikely to be used but worth further inspection; yellow are possibles; green are first selects. Untagged images will likely be deleted.

Challenge Checklist

→ A preliminary step is to always back up your images to not one, but two separate drives. Just because you copied the files to your computer does not make them secure!

→ Explore your particular program's tagging and organization tools, and decide which ones are relevant to your workflow.

→ While creative naming is fun, a standard file-naming convention, usually consisting of the date of the shoot, will help you keep track of the files across your various hard drives.

→ Then make adjustments

A different route would be to use Lightroom or some other workflow-oriented software, that combines the sorting/organization step with the Developing step (and even includes an Output step, all in one package).

Review

I edit in Lightroom and Photoshop. Lightroom is particularly advantageous for B&W photography, as it's non-destructive method leaves your originals untouched. My editing process is as follows:

1] Import into Lightroom, sorted by date. Group dates into tagged events, shoots, or trips. I select photos in two passes. First, I hide all the "bad" shots: improper exposures, poor compositions, unfocuses shots, etc. Next, I go back through the remaining shots and select the "good" shots: the best from each angle and scene.

2] I always create a virtual copy and convert that to B&W. This way, if I want a color copy, I have it easily on hand. First, I raise white and lower blacks until my histogram is just inside the edges. I also add a bit of fill light as needed. Next, I hop down and play with individual color channels, and check white balance and tint. Finally, I set curves, and go back through the steps till I'm satisfied.

3] For major editing (image masks, fixing facial blemishes or hair, image grain filters, etc.) I export to Photoshop.

Josh Ryken

That's a sensible and straightforward workflow, with some tweaks to suit your personal style, like removing rejects from view without deleting them. By making a virtual copy of an image that you're about to convert, you take advantage of the Lightroom way of doing things, and this underlines that workflow of any kind in digital photography is strongly affected by the software you choose. In the end, it becomes a mixture of the features that the software designers are offering, and your own personal style. Because Lightroom protects originals, so that they are not overwritten, is clearly very useful to a black-and-white conversion workflow. For various reasons, I use Photoshop rather than Lightroom—they're from the same stable, of course—and I do my conversions in post-production, after the Raw processing. That means I have to be a bit more careful to avoid over-writing a TIFF, and I give a different filename, adding the suffix "bw." Everyone's workflow is different.

Michael Freeman

Key Colors

One way that we as photographers can utilize color to our photographic advantage is to seek out and capture scenes in which a single color plays a vital role in the success of the composition. This could be a red jacket in a sea of navy blue, black, and gray; or a broad swathe of red flowers set among a mass of green foliage. It's not so much that the key color itself is any way extraordinary, but more how it contrasts with the rest of the colors in the image.

When assessing a color image in which its success relies on a single color you have to make two fundamental decisions—firstly, whether the visual impact of the color will translate into black and white, and secondly, how the dominant color will contrast tonally with the other hues.

↓ **Worm's Head, off the coast of Wales**
This narrow strip of land is entirely cut off at high tide. This image shows the feature at low tide, and although the color of the green grass is not exceptional in itself it provides a strong contrast to the turquoise ocean, blue sky, and the textured brown rocks in the foreground, and helps to lead the viewer's eye through the image to the head of the land feature.

© Steve Luck

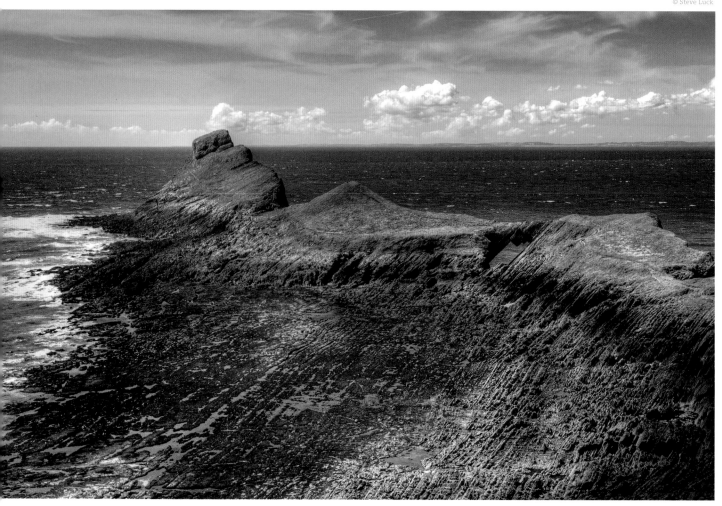

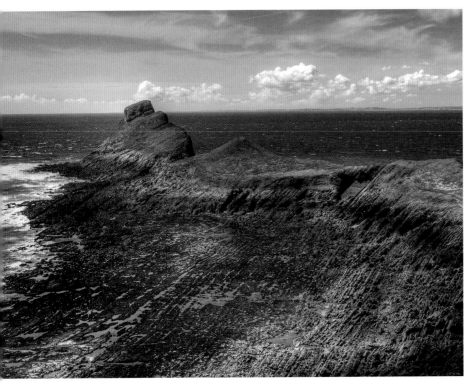

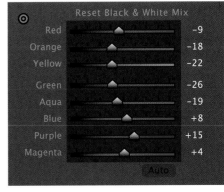

←↑ The automatic interpretation

Lightroom's default black-and-white conversion fails to pick up on the significance of the strip of green grass, and the result is that the narrow landmass is lost between the ocean in the distance and the rocks in the foreground.

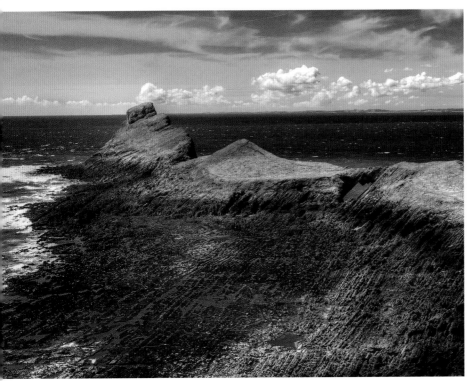

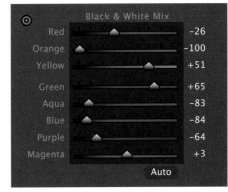

←↑ The creative interpretation

Using the black-and-white target adjustment tool it's possible to isolate the greens and yellows of the grass and lighten the tones of those specific hues, while at the same time darkening those colors associated with the ocean and to a lesser extent the sky, namely blue and aqua. Reducing the red and orange components helps to differentiate the grass from the rocks. Having made the adjustment, the landmass once again is isolated from the rest of the scene, and in this way remains true to the original color version.

Dominant Colors

↓ An appetizing start

When assessing this shot of a piece of cheesecake drizzled with raspberry jus and accompanied by raspberries and a green leaf, it's clear that a monochrome version needs to appear "realistic." After all, we're showcasing food, and the image needs to appeal to our sense of taste, rather than act as a pure visual spectacle.

As we've seen, the black-and-white conversion tools we have at our disposal today provide a high level of control—affording us a wealth of possible creative decisions to make if our monochrome conversion is to be successful; and that's particularly true when the color image in question contains one or two dominant colors. We need to assess whether or not the colors will retain their visual impact when shown in black and white, and also how they are going to contrast with the other hues in the image. With the versatility now offered by black-and-white conversion tools it may be possible to set the dominant color dark and the other elements light, or vice versa. Ask yourself how "naturalistic" the black-and-white image should be. Should it be an accurate grayscale representation, or can you be more dramatic for greater visual impact?

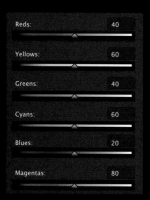

Reds:	40
Yellows:	60
Greens:	40
Cyans:	60
Blues:	20
Magentas:	80

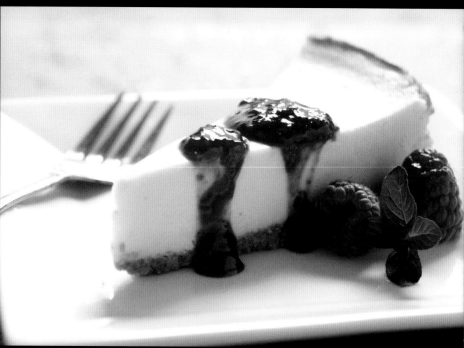

← ↑ Lost in the conversion

The default settings have rendered the raspberry jus and the raspberries themselves quite dark. The jus looks more like treacle and the form of the raspberries is not clearly discernible. Good visual contrast but not particularly appetizing.

→ Restoring the appeal

Lightening the reds has the beneficial effect of rendering the raspberries more visible and making the jus more attractive. Generally, the image appears softer and lighter. We've lost the color contrast between the red fruit and the green leaf, but it was necessary to brighten the green tones as well as, because the leaf looked wrong when rendered darker than the fruit. The lighter tone also helps to illustrate the leaf's delicate form.

Reds:	74
Yellows:	0
Greens:	218
Cyans:	68
Blues:	30
Magentas:	53

Hue:	0
Saturation:	16
Lightness:	0

✓ Colorize

←↓ With a tint

A quick and easy way to introduce some color to the grayscale image, but still render it monochromatic, is to click the Colorize button in a Hue/Saturation adjustment layer dialog. Keep saturation low and select a hue that complements the subject matter.

Challenge Checklist

→ Assess the image to ensure you can successfully isolate the dominant color when converting to black and white.

→ Remember that some opposing colors, such as red and green, share similar grayscale tones when converted to monochrome. What contrasts in color may not do so in default monochrome.

→ Think about the overall impression you're trying to create. Are you going for stylized, high-contrast impact, with the dominant color much darker or lighter than other elements, or are you opting for a more "realistic," monochrome conversion?

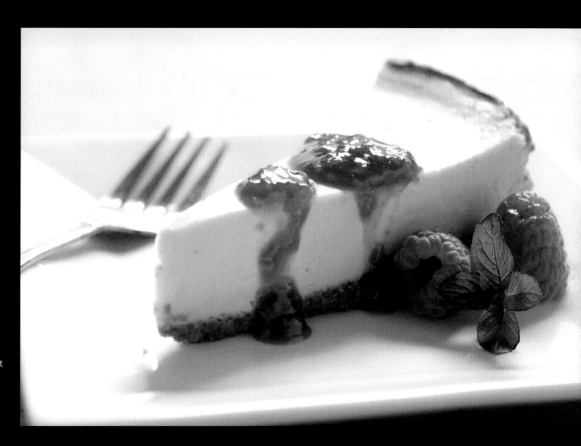

Review

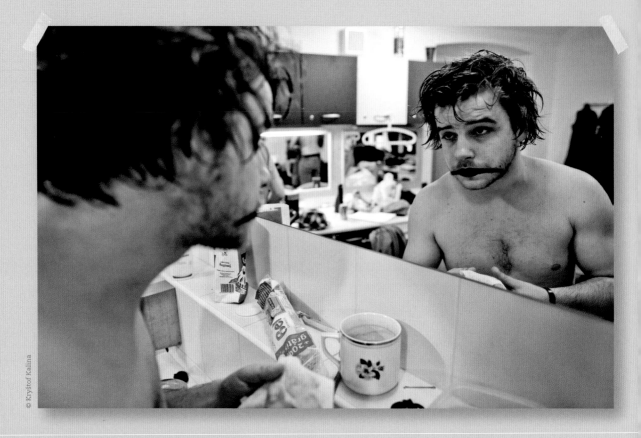

© Kryštof Kalina

A photojournalist shot from backstage at Prague's DISK theater. The essence of such pictures is to establish a personal relationship between the viewer and the subject, and an over-the-shoulder framing evokes such a dialog. I converted to B&W to accentuate the contrast between a dull dressing-room interior and the last remaining artifact of just-finished play. It is all over, except for this lasting black smile (kept very dark relative to other colors in the conversion) surrounded by gray, everyday reality.

Kryštof Kalina

The over-the-shoulder intimacy lets us participate in the actor's silent dialog with himself. The black gash of the mouth jars with everything else, (nice touch on the curve of one side visible on the actor's face at left, confirming that it is indeed painted on), making the picture a useful study in reality versus artifice.

Michael Freeman

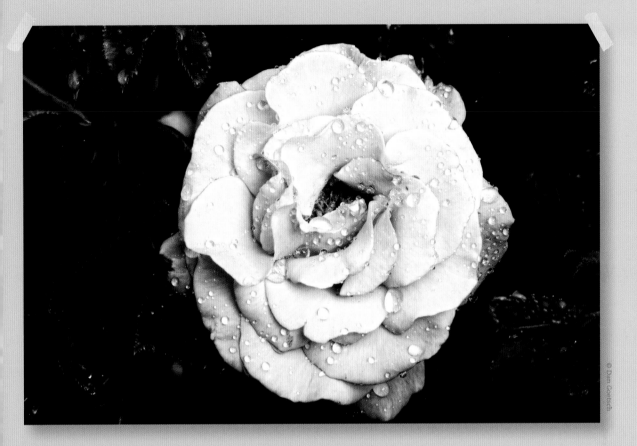

© Dan Goetsch

When I was editing, I noticed the hue of the flower was such a deep red that the droplets were incredibly hard to see. I converted it to B&W and brought the red slider way up to invert the flower to white instead. From there I brought the blues down to darken the foliage around it and add contrast.

Dan Goetsch

Red is one of the most difficult colors to convert into B&W because it's the very redness that punches out in a color image, and there is no equivalent in monotone. We're left usually with the choice of making it dark (but a black flower has some very odd associations—Black Dahlia and all of that), or as you've done here, white. The droplets remain, although of course in the color original they inevitably sparkle more because of the bluer highlights they pick up.

Michael Freeman

Separating Colors

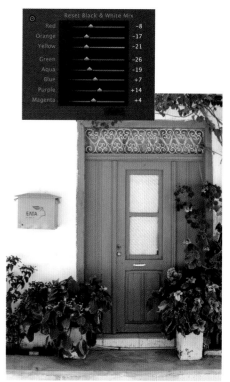

Black-and-white conversion can and should extend further than simply attempting to recreate a faithful monochrome equivalent of the original color. Fortunately, the highly versatile monochrome conversion tools we have at our disposal allow us to experiment freely in order to find not what necessarily looks most authentic when compared with the original, but what has the greatest impact as an independent black-and-white image. The most striking results are to be obtained from complementary colors— those that sit opposite one another on a standard color wheel; and the more saturated the colors, the more striking the effect. What's more, the sheer versatility of the available black-and-white tools should, in theory, permit you to create two monochrome versions that tonally are opposite one another.

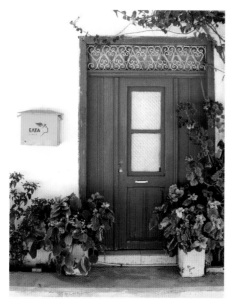

© Steve Luck

↗ → ↘ Capitalize on contrast

Although not completely complementary, blue and yellow are almost as far apart on a color wheel as you can go. A default black-and-white conversion, however, barely distinguishes the two colors as they have a similar brightness value; so clearly manual intervention is needed. With such highly saturated colors, the sky's the limit as far as the conversion is concerned. Increasing the yellow luminance while decreasing the blue provides a somewhat more dramatic equivalent of the color original. However, we don't have to stop there. By reversing the luminance values of the blue and yellow sliders we get an entirely opposite result, most noticeable in the lettering on the Greek mail box.

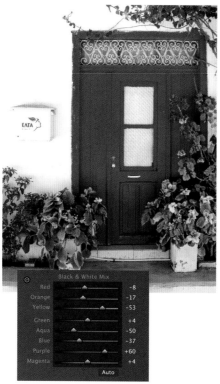

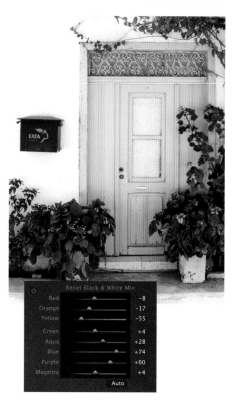

While complementary colors provide us with a means of creating dramatic, contrasting monochrome images, colors that are much closer to one another on the color wheel, or indeed next to each other, can be much harder to separate. Yet, if the image is to succeed in black and white it's important that this can be achieved.

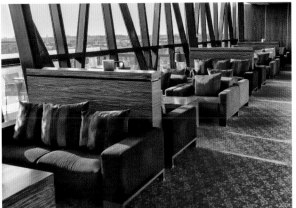

← Common colors

This hotel lounge utilizes soft furnishings, furniture, and a carpet that between them share a number of similar colors. The trouble with colors of a similar hue, is that when you adjust one, you're in danger of affecting another.

↓ Step one: auto-conversion

The default conversion has made a brave attempt at separating out the colors, but the stripes in the cushions could be more clearly delineated.

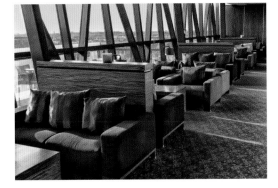

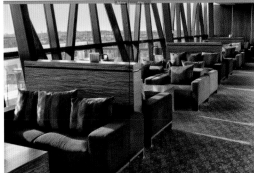

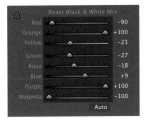

↖↑← Push to the extremes

In these circumstances, if possible, utilize a before-and-after preview screen so that you can identify the colors that you're attempting to separate out. In this particular example it's clear that the red, orange, purple, and magenta sliders will have the greatest impact.

Experimenting with those four sliders at various extreme settings provides a range of results to choose from. In the end, the settings shown above provided the best results—the stripes in the cushions are more pronounced and the tonal difference between the carpet and the brown fabric on the chairs is clearer to see.

Tonal Distinctions

Learning how to tease colors apart is crucial for successful monochrome conversion. Complementary colors—those sitting opposite one another on the color wheel—are quite easy to distinguish, while more subtlety is required for colors that sit adjacent to one another. But, perhaps if the success of the black-and-white version comes down to distinguishing between blue and purple, say, then it may indicate that the image isn't right for a monochrome treatment. Returning to complementary colors; while it may be easy to differentiate them tonally using different color sliders, there still remains the issue of interpretation. Saturated complementary colors can be rendered in so many different ways that it's often a case of trial and error to see which version works best.

→ Tuscan farmhouse
Comprising primarily of blue, green, and red tones, this image should permit a good degree of monochrome variation. The issue again comes down to interpretation and taste—and to a certain extent whether or not the purpose is to stay "true" to the color version.

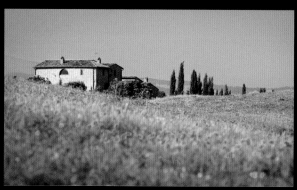

© Grischa Georgiew

↙↓ Lost in the tall grass
As you'll discover when converting to black and white, the near complementaries of green and red are, by default, barely distinguishable. In this particular example, the failure to separate the red poppy flowers from the green stalks and leaves essentially makes the default monochrome version of the image meaningless.

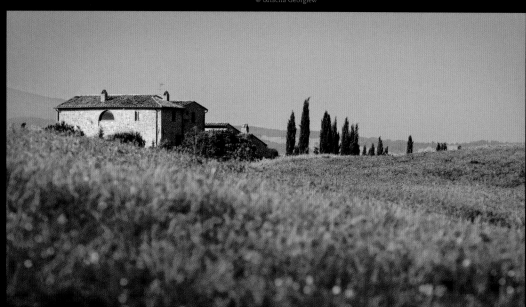

Reds:	40
Yellows:	60
Greens:	40
Cyans:	60
Blues:	20
Magentas:	80

Challenge Checklist

→ Assess the hues in the color image and decide whether they are complementary or adjacent. If the latter, you won't be able to adjust one without affecting the other when converting to black and white.

→ Previsualize how you want the monochrome image to look, and decide on which elements you want to emphasize when monochrome.

→ It's worth experimenting with the color sliders, particularly with rich complementary colors, as it's possible to reverse tonal values completely, giving strongly opposing looks and interpretations.

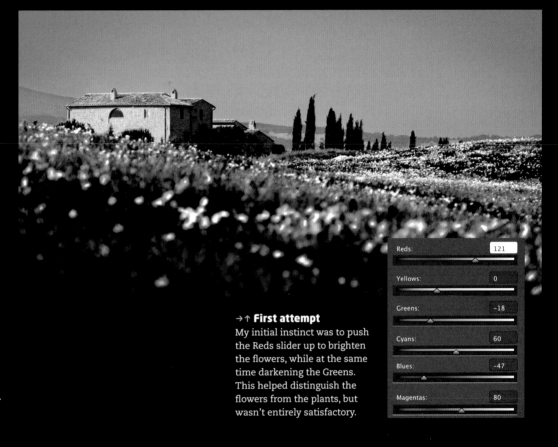

Reds:	121
Yellows:	0
Greens:	−18
Cyans:	60
Blues:	−47
Magentas:	80

→↑ First attempt
My initial instinct was to push the Reds slider up to brighten the flowers, while at the same time darkening the Greens. This helped distinguish the flowers from the plants, but wasn't entirely satisfactory.

Reds:	−79
Yellows:	103
Greens:	94
Cyans:	44
Blues:	−38
Magentas:	103

↑→ Final interpretation
Reversing the Reds and Greens and increasing the Yellows works better in my view. Not only are the flowers clearly differentiated but the roof of the house contrasts well now, and the trees are a better tone. The sky was left neutral.

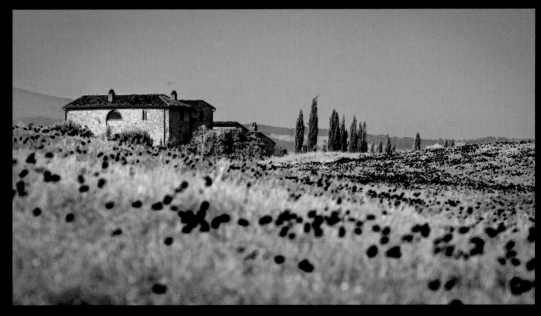

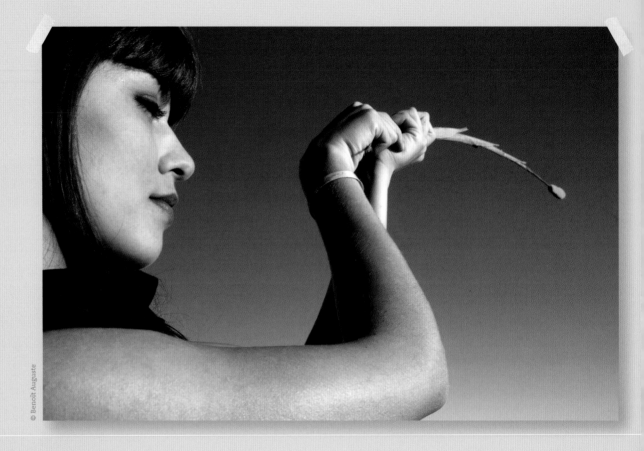

© Benoît Auguste

This was shot in a field, on a bright, clear day with a deep blue sky that contrasted brilliantly with the tan/orange skin of the subject. Wanting to exploit this contrast, I angled the camera up to use the sky as a clean backdrop, and got in very close (this was shot at 28mm) to emphasize the graphics of her twisting arm.
Benoît Auguste

Whatever she's doing, the result is a swan-like curve that, along with her concentrated expression, takes over the frame and the image. The low sun gives great modeling, and the total effect is a concentration on form. One of B&W's traditional strengths is that it gives full expression to form, by removing the competing interest of color. I suspect the blue of the sky would make stiff competition for attention, but toning it down in the conversion makes it instead into a contrasting dark background.
Michael Freeman

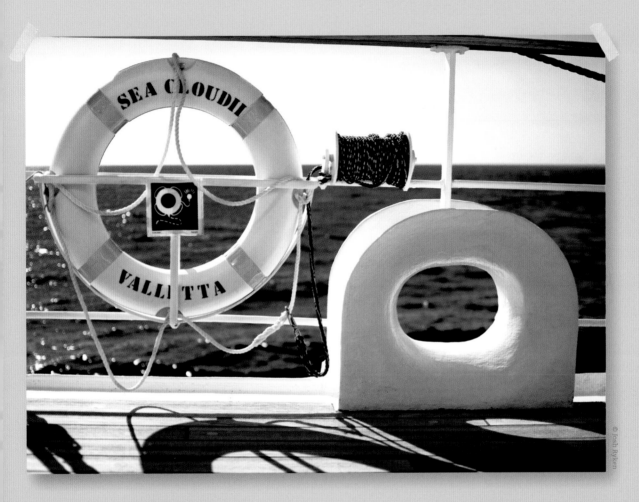

When first rendered in B&W, the orange life ring and the blue water were virtually the same shade. I had to choose how to distinguish them, which I accomplished by brightening the orange and darkening the water. Unfortunately, this left the deck of the ship too bright, so I had to tease it darker using the yellows.

Josh Ryken

To me, this breezy contrast and various shades of white, in and out of shadow, has a Modernist feel from the '30s or '40s, which shows how different B&W can be from the reality. These whites include a hidden orange, and while common sense tells us that a life ring should and would be orange, it seems to our eyes that it really is white. The top right slope of the rail bothers me a bit, but then I can see from the deck line also that the culprit is the usual barrel distortion so common in today's zoom lenses.

Michael Freeman

Creative Decisions

In the next section we'll be looking in more detail at the types of photograph that have become synonymous with black-and-white photography. However, before we get too specific about identifiable monochrome treatments and styles, and while the conversion process is still fresh in the mind, it's worth spending some time thinking about the possibilities that the absence of color throws out—and how we can start to exploit those possibilities.

There are essentially two ways of arriving at a black-and-white image. The first is by reviewing shots you've taken (ideally in a Raw format) in your editing suite and converting those that you think will work as monochrome.

Usually, there's a quick key stroke that you can use to give you a black-and-white preview. You can then spend further time refining any that look promising. Often you'll be successful and produce a striking black-and-white image. But this approach is clearly somewhat hit or miss. Better is to first look carefully at those images that have successfully transferred from color to black and white, and identify why they work. It could be a repeated pattern, a texture, the relationship between the highlights and shadows, or a smooth gradation in tone.

Having identified what works in monochrome with the digital darkroom, the next time you're out

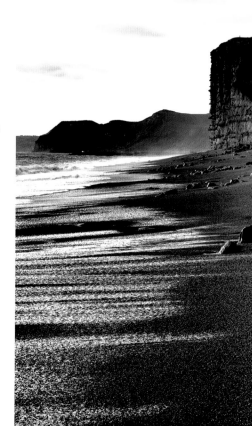

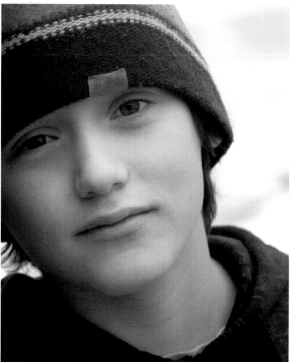

← Concentrate on character
In many respects the absence of color renders black-and-white photography extremely versatile, and some would argue more so than the color form of the medium. Black and white can render smooth, soft tones that emphasize shape and form, as in the image of this teenage boy; and the lack of color forces the viewer to appreciate more the subtle nuances of tone.

↑ Necessary B&W
Yet monochrome photography is equally adept at high-contrast imagery, in which drama is created by the juxtaposition of black and white tones. A similarly toned color version would only emphasize the fact that the highlights were blown out, spoiling the pleasure of viewing the interplay between light and dark.

→ Forest through the trees

As you come across scenes such as this tangled mass of beech trees, you should be thinking and aiming to capture texture, line, and form, seeing through the colors that are present. A high-contrast approach that emphasizes light and shade so attention is drawn to the angles in the scene, whereas a more even-toned approach would reinforces depth and texture.

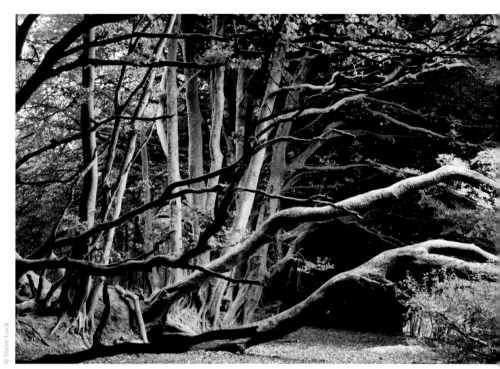

shooting try to think in advance about creating a monochrome image. Train your brain to ignore color and look instead for form, tone, texture, and line. Learning to see in black and white takes time; but as you begin to do so, you'll discover that, without having to adhere to the realism of color, you'll quickly come to appreciate how many creative options you have. Super-high-contrast black-and-white photography, for example, allows you to forget about holding the highlights—let them blow. The traditional "film noir," low-key image means you don't have to worry about shadows filling in. Colors clashing? In monochrome they could translate into a smooth tonal nuance.

Black-and-white photography gives you the opportunity to go way beyond realism, it permits and encourages total self-expression. While most potential scenes will have caught your attention for a specific reason, whether it's texture, form, or tone, you'll also begin to discover that many scenes can be interpreted in a number of ways when considered as a monochrome image.

→ Nothing is beyond black and white

Although you might think that a conventional landscape showing a sweeping vista would be less successful in black and white than color, a monochrome treatment asks the viewer to assess the image for tone, line, and contrast perhaps more than would be the case when viewing a color version. In this particular image the absence of color reinforces the quiet serenity of the scene, and creates a more timeless quality.

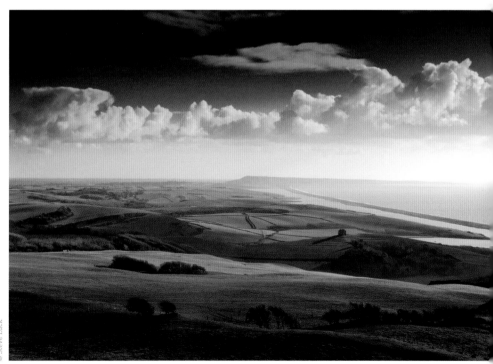

A Personal View

↓ **Graphic or literal?**
This image from a maritime museum showing old chains and ropes has a number of potential monochrome conversions. One option involves highlighting the texture and form of the chains and ropes, another option would be to accentuate the graphic possibilities of the various elements in the scene.

Most color images can be converted to monochrome in a variety of ways—ranging from "accurate" grayscale versions that provide a realistic result to a stylized, high-contrasting image that accentuates the graphical elements present in the image, with a whole host of options in between. Which conversion route you take will depend on what you want to achieve with the monochrome image. If you're looking to emphasize form and subtle nuances of texture, for example, you want to downplay the relationship between light and shade and open up the mid-tones so that as much detail as possible is visible. Alternatively, if you're looking to explore the graphic potential in an image, the opposite is true. Use all the tools available to darken shadows and brighten highlights. The resulting high-contrast image will emphasize shapes and outlines.

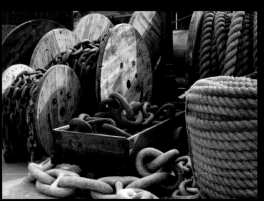

© Steve Luck

R 64.3 G 64.3 B 64.3 %

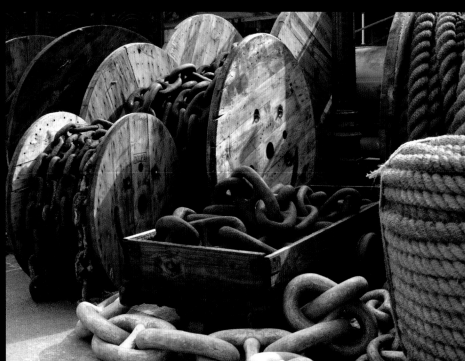

↖↑ **A good first step**
The default black-and-white conversion is much as we would expect—a pretty accurate monochrome representation of the color image. The histogram shows a good range of tones from black to white.

→ Low-contrast mid-tones

The first alternative version to the default aims to accentuate the form of the chains and ropes. The best approach is to use tools that reduce contrast and increase the mid-tones, such as Levels or a reverse S-curve. The aim is to create a histogram in which there is less emphasis on the blacks and whites, and a greater concentration of gray tones. With few saturated colors present, the black-and-white conversion color sliders have a minimal role to play in this particular example, although they could be used in other images to equalize tones.

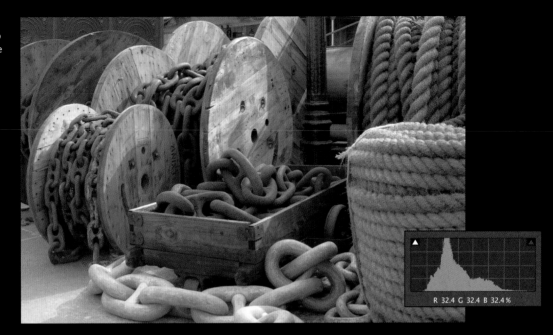

R 32.4 G 32.4 B 32.4 %

Challenge Checklist

→ When assessing a color image (or indeed a scene you're photographing) for a monochrome treatment, think about what it is you want to emphasize— form, texture, line, pattern, and so on.

→ Use brightness and contrast controls (and if applicable black-and-white conversion color sliders) to control global and local contrast that accentuates the very characteristics of the image that attracted you in the first place.

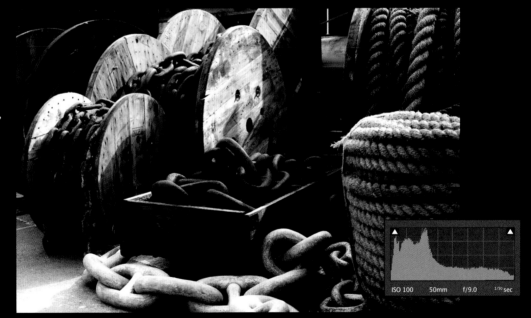

ISO 100 50mm f/9.0 1/50 sec

↑↗ Deep in the black

In the second alternative we're looking to highlight lines and edges so that shapes are made more apparent. This is achieved by increasing contrast (again using commands such as Levels or Curves) to create a histogram in which more pixels are pushed to the extreme edges and tonal gradation is suppressed. The result emphasizes the round shape of the chain drums and the rectangle created by the wooden box.

Review

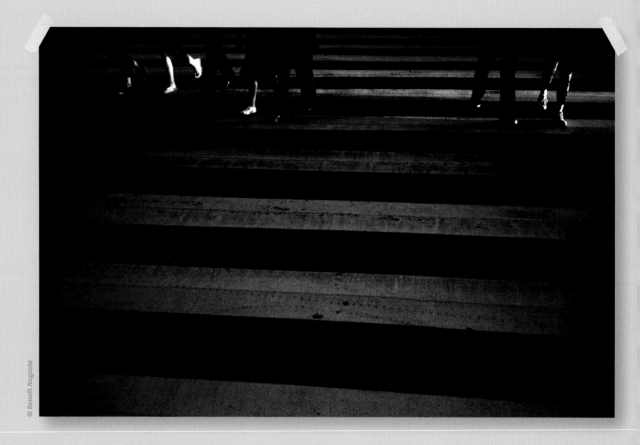

© Benoît Auguste

My first thought was to crank up the contrast and have pure black and bright white lines dominating the frame, but the results looked too obvious, and in general I do prefer a low-key treatment. Pulling the entire histogram over the the left captured the mood of this street scene much more faithfully.

Benoît Auguste

An experimental composition that could succeed even more with a few tweaks in processing. The vignetting is not necessarily a bad thing, but in this case it stops the lines in the lower two thirds of the frame from being evenly toned. As a result, our eyes drift down to the lower center, when I suspect you really want them to stay up with the feet of the pedestrians. Again, a lens profile correction during processing should sort it out, and might also help the outer feet at left from disappearing.

Michael Freeman

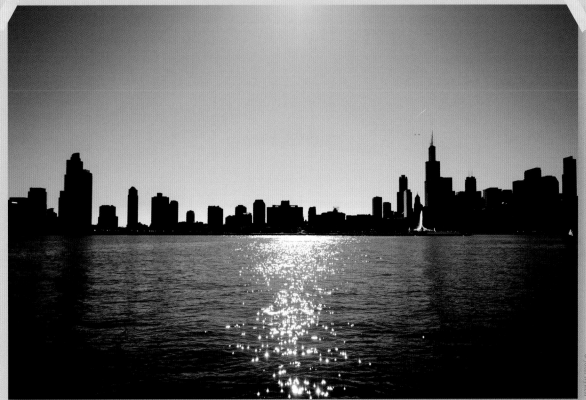

© Josh Ryken

I had a choice to make when editing this photo: Do I want lower contrast to showcase the details on the buildings, or show just the shape of the skyline using higher contrast? I decided on high contrast, showcasing the unified form and strength of the Chicago skyline.

Josh Ryken

Now here's a case where the same vignetting as on the opposite page works to help the image by enclosing the centralized composition and concentrating our attention on the center and the cascade of glittering reflections. From a lens manufacturer's point of view, vignetting is undoubtedly a fault, but for photographers it gives the possibility of a tunneling effect like this. As for your choice of opening up or going for silhouette, that seems entirely the right one to me.

Michael Freeman

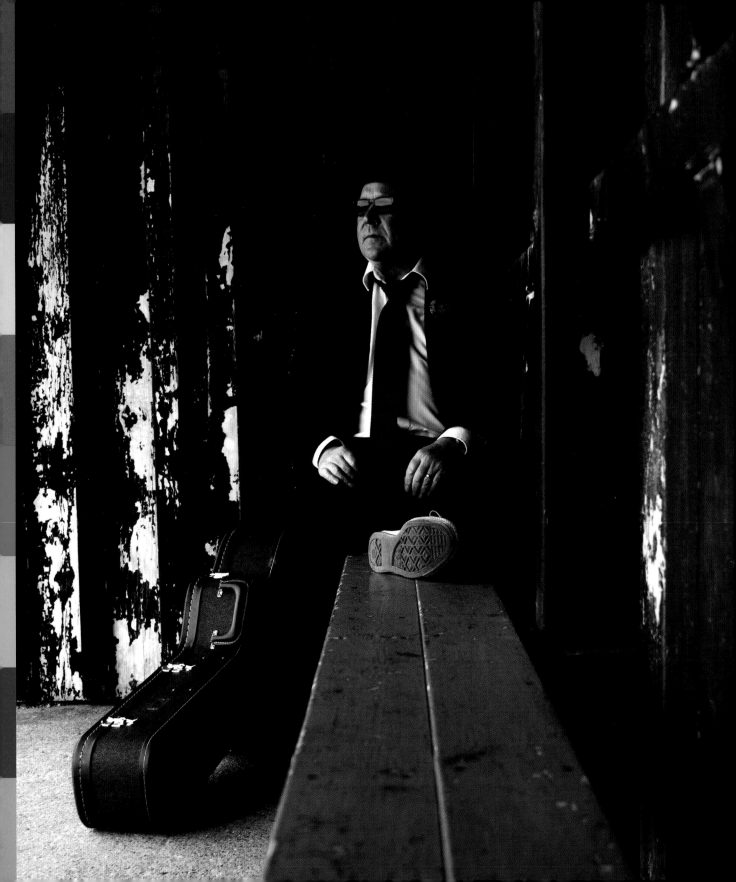

The Black & White Tradition

Why is it that for the many millions of amateur photographers born in the 1970s and after, and who grew up with color ubiquitous across all media, that black-and-white photography still retains an elevated position in the genre? The answer is at once complex yet simple at the same time. Complex as it has to do with the history of photography, when so many of the masters of the genre from whom we have learned so much could only work in black and white, and when, despite the emergence of fledgling color, black and white was still perceived as authoritative and having a greater "reality" than color. And yet simple because the absence of color allows us to explore more freely the graphic possibilities, tonal relationships, forms, and textures of the scenes we encounter.

In other words, black-and-white photography, as well as having a tradition that sets it apart from the mass of color snaps, also has definite practical advantages that allow us to enter into a more creative, "artistic" world that is by its very nature removed from a color reality.

A Separate Reality

For the most part, color photography has at its heart representation—we expect to see the colors in a photograph represented more or less how they appear to us in real life. The same does not hold true for the black-and-white image. Devoid of color, a monochrome image cannot accurately depict how we see the world—straight from start, when it comes to black and white we're one step removed from the reality of color. Ironic perhaps, that as some observers have noted, it was black and white's pedigree as the official recorder of world events from the 1930s until the 1960s—the time of the most recognized work of some of the greatest documentary photographers—that for a while, even after the advent of color film, we perceived black and white as somehow more authentic than color. And yet we have to ask, if black-and-white photography hadn't come into existence through necessity, would it ever have existed at all?

Whatever your personal views are on that particular question, one thing is for sure, black-and-white photography existed as the only viable form of photography for so long (and perhaps also during a period of such great social upheaval) that it is still venerated today by many as the true language of photography. For such people, black and white is the more refined version of photography, an art form compared with its more vulgar color counterpart.

Being the dominant form with such an established history and photographic repertoire, it's hardly surprising that the separate reality, of which photo reportage is an excellent example, moved into a more surreal arena. With no constraints of color realism to adhere to, photographers became increasingly experimental with the black-and-white image (also partly driven by advances in black and white emulsion and the lighting techniques of Hollywood). Out of this reality emerged styles of photography that today are very familiar to us—high and low contrasting scenes, smooth toning, and high-key and low-key images. And it's these styles that we'll examine in the coming pages.

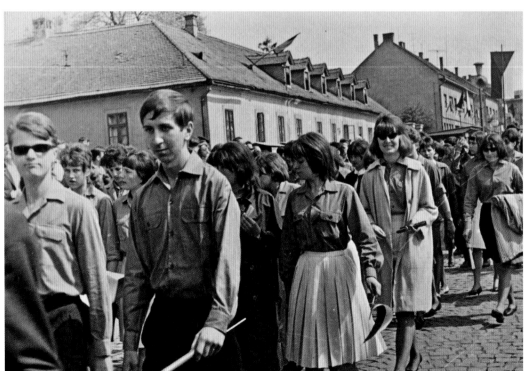

← **Communist parade**
A combination of factors (new, discreet 35mm film cameras, relatively high-ISO film that came only in B&W) made black and white emerge as the medium of choice for documentary photography—such that to this day we can be more inclined to accept a black-and-white (or, in this case, monochrome) interpretation as authentic and visceral than a color version (even with the full knowledge that digital black and white begins with a full-color image). This shot of young communists marching through the streets of Moscow in the 1930s likely looks more realistic than if it was crisp and in full color.

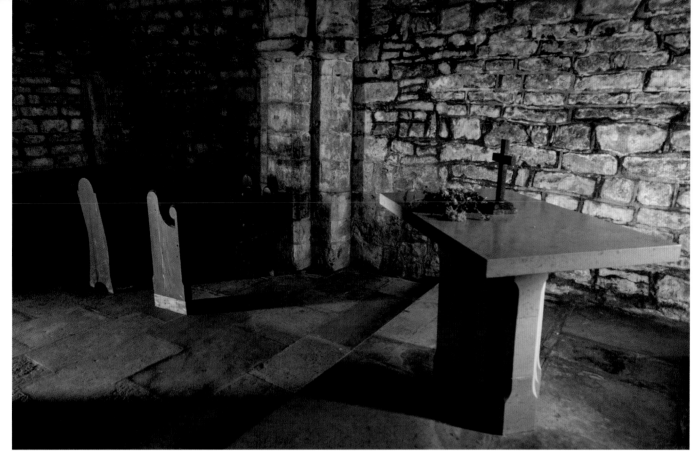

© Steve Luck

↑ No role for color to play

Color had almost no role to play in this shot of the interior of a 13th-century chapel in southwest England. The absence of color helps to emphasize the tonal and textural qualities of the image.

→ Look closer

Street photography, like its close relative reportage, has long been associated with black and white. For many street photographers shooting monochrome film is the only true expression of the genre. Again, the lack of color encourages a deeper viewing of the scene.

© Steve Luck

© Steve Luck

↑ Go for graphic

Black and white allows the photographer to behave in a more extreme way when it comes to exposure and contrast settings. This freedom can often result in powerful graphic images that are more concerned with creating impact than accurate representation.

Strong Graphics

There's no two ways about it, color is intoxicating. Just think about how you respond to an orange-red sunset or an azure-blue ocean—these and innumerable other examples all create deeply felt, emotional responses.

So in a monochrome image that is devoid of color, our natural reaction is to seek out other qualities. But what is it that we're left with if we remove color? Well, naturally the subject remains the same, which is why few people question the use of black and white in reportage, but so does the structural composition of the image— its line, shape, and form, its contrast and tone, and its texture. Without color to distract us, these elements assume a greater significance.

Look through any collection of black- and-white images, and the ones that jump out at you will have strong lines and shapes—graphics that provide structure and help guide the viewer through the image. Form, as we shall go on to see, has a different connotation, being more concerned with three- dimensional volume rather than the flat, two-dimensions of shape. Lines are ubiquitous, found in natural as well as artificial environments. Some are curved, some are straight, some are horizontal, others vertical, and yet more are diagonal. These different forms of line, as well as leading the eye, also elicit powerful emotional responses. Diagonal lines, for example, being neither vertical nor horizontal, can create tension, as can tightly

formed curves. While horizontal lines and more sweeping curves tend to produce a feeling of calm.

Shapes, whether geometric, such as triangles, squares, and circles, or nongeometric can be used as the building blocks of composition, and if repeated can have real impact.

Key to how much impact graphics have on an image is contrast. If the lines and shapes are made of dark and bright tones juxtaposed to one another, they will create a strong and active impression. When processing images to show off strong graphics look to increase contrast as much as possible. Whether or not you clip highlights or shadows depends on the image.

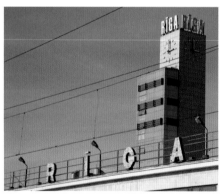

© Steve Luck

↑→ **Rail station at Riga**
Although the graphic qualities of this image from the Estonian capital exist in the color version, a high-contrast monochrome treatment helps to accentuate the frontally lit, late 20th-century Eastern European architecture and retro lettering. The power lines, although partly a distraction, help to lead the viewer through the picture, mirror the angle of the bridge, and add dynamic tension to the image.

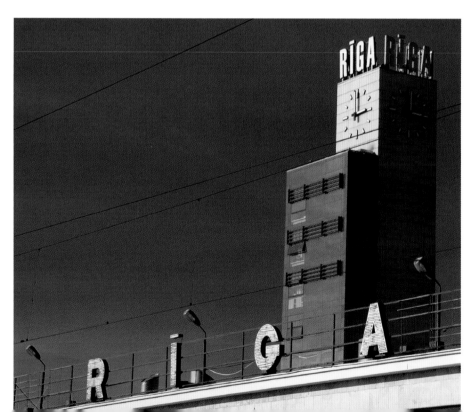

→ Make the most of design

This formal 17th-century room features a marble floor with a strong geometric design. The pattern emphasizes the size of the room and leads the viewer to its distant corners and doorways—all helped, of course, by the contrasting nature of the materials used in its construction.

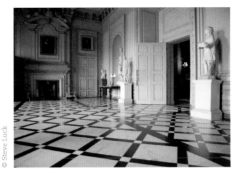

© Steve Luck

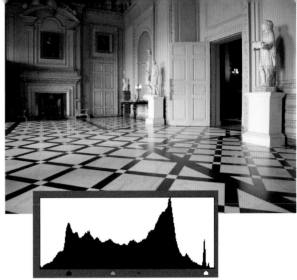

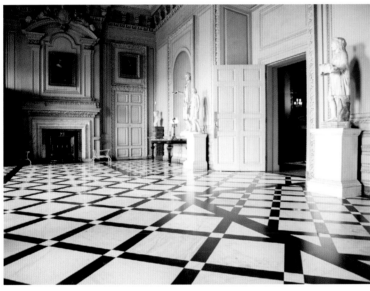

Tone		Auto
Exposure		+1.05
Contrast		+56

←↑ Be aggressive with the sliders

In order to emphasize strong graphic elements, when processing utilize tools and controls that help you add contrast. With this particular image I increased the Exposure to brighten the entire image, then increased Contrast to darken the dark to middle tones, while at the same time lightening the middle to light tones. Using Levels, increase the brightness of the gray point slider and clip the blacks for a high-contrast effect. Remember, you can be much more aggressive with the controls when in black and white than you would be with a color image.

© Steve Luck

→ Silhouetted graphics

Shape relies on outline, and the most extreme expression of outline is silhouette. Shot against a late afternoon sun, the subtle form and texture of the trees are lost, leaving only clearly defined, two-dimensional shapes. Although natural graphic possibilities tend to be less geometric than artificial ones, they can still be successfully exploited; and when done so with black and white there's less reason to fear either highlights or shadows clipping—it merely adds to the graphic nature of the image.

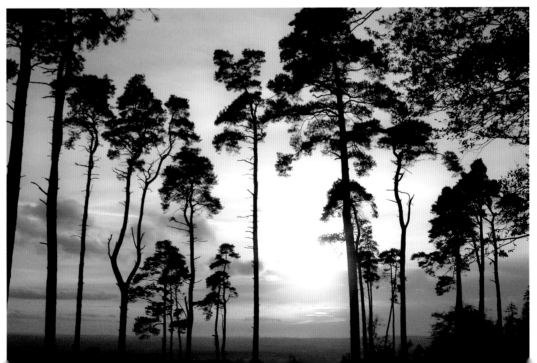

Beyond Clipping

↓ Start with a good subject
This image of towering office blocks has plenty of graphic possibilities. There are clearly defined, regular shapes and lines that contrast well with the more amorphous clouds above. The aim here is to use extreme settings to emphasize this contrast as much as possible.

Throughout the course of this book, you'll be learning how working in monochrome gives you much more freedom to experiment with tonal extremes. In most cases, when working in color, we're looking to present a realistic impression of a scene, but that's less true with black and white. In this challenge look to really explore the tones in the image, and push tonal adjustments such as Curves or Levels commands to the extreme. You're not trying to produce an accurate reportage image here, you're looking to examine the relationship between light and shade, and wherever possible to emphasize other compositional elements such as line, shape, form, texture, balance, and so on. Use all the tools you have at your command to play around with contrast. Black-and-white conversion tools, for example, allow you to target specific colors, while you can use Curves to adjust overall tone.

Reds:	40
Yellows:	60
Greens:	40
Cyans:	60
Blues:	20
Magentas:	80

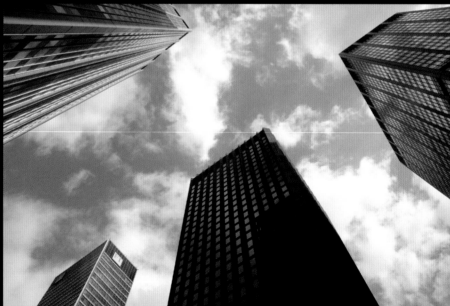

←↑ Auto conversion first
The absence of color in the default black-and-white version goes some way to highlighting the strong, powerful vertical lines and

Challenge Checklist

→ Seek out images in which strong graphic shapes are clearly outlined.

→ Be bold with your contrast adjustments; remember you can be far more extreme with black-and-white images than is usually possible in color.

→ Deliberately clip highlights and shadows using a Curves or Levels command to create a two-tone image that emphasizes line, shape, and pattern.

Reds: 19
Yellows: 50
Greens: 22
Cyans: 29
Blues: -200
Magentas: 56

← ← ↓ Pushed to the extremes

An extreme Curves adjustment clips both the highlights and shadows, rendering much more of the image as pure black or white. Next, by reducing the Blues slider the blue component of the sky is turned black, setting up a powerful contrast with the white clouds. The final result is a powerful graphic representation of the color original. The image is almost entirely black or white, which has greatest impact on the windows which now form a strong grid pattern.

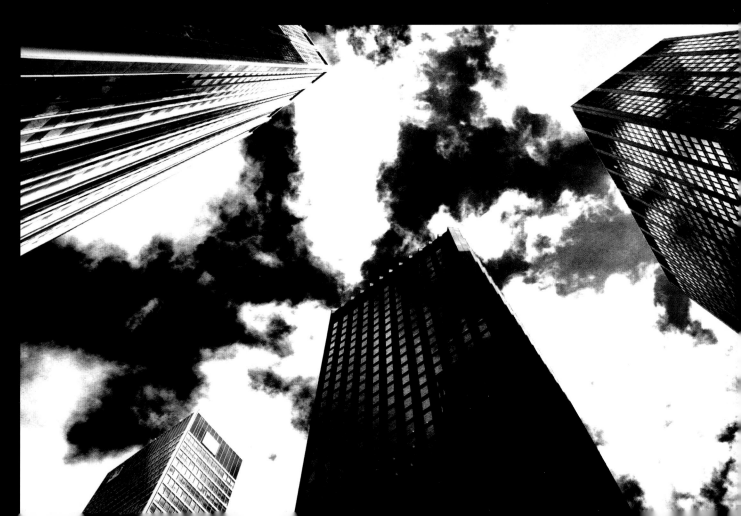

Review

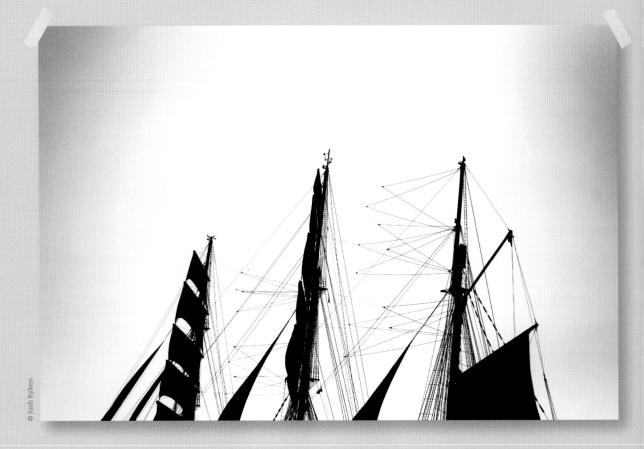

© Josh Ryken

This photo of a square rigged ship was taken with the sun high and behind the ship. The unedited photo is particularly mediocre: overexposed, with washed out colors, and harsh shadows. However, when pulled to extremes, the beautiful shape of the lines and sails is revealed.
Josh Ryken

The extreme conversion processing has certainly brought out the silhouette of sails and fine rigging in great detail. The vignetting in the upper corners does a job of centering the view, but I'm not sure if it does enough to make compositional sense of the loose upper part of the frame. You cropped strongly and unexpectedly at the bottom, which is fine, but it makes me wonder what a longer focal length would have done—a frame completely inhabited by sails and rigging.
Michael Freeman

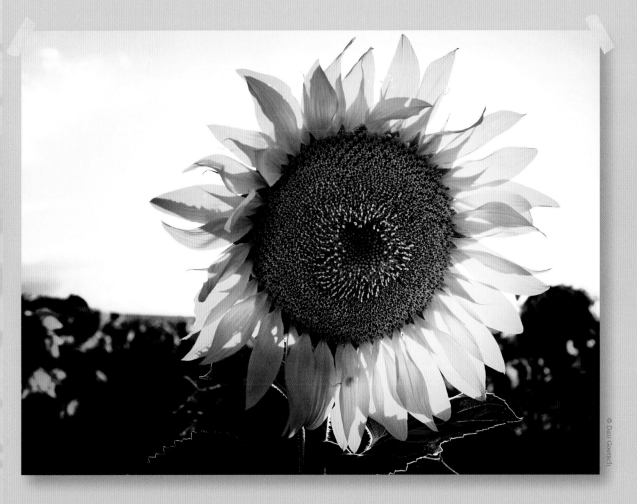

The sun was going down behind the flower to the right and the light was shining through the petals. To get the details to come out in the center of the sunflower, I had to sacrifice the light in the background. This worked great for a B&W conversion because of the outlines you get with the petals on the bright sky.

Dan Goetsch

How much stronger in B&W than in color, and not just to escape blown-out highlights. Contrast really is the key, and you've brought the yellow and red sliders in to do their job on this. Green leaves have gone black, the subtle blue in the sky gives it some presence, and the yellow petals are excellently rendered. But what I like most is your treatment of the flower's center, accelerating the contrast while lightening to give an effect for which some people might use fill-in flash.

Michael Freeman

Subtle Shading

© Steve Luck

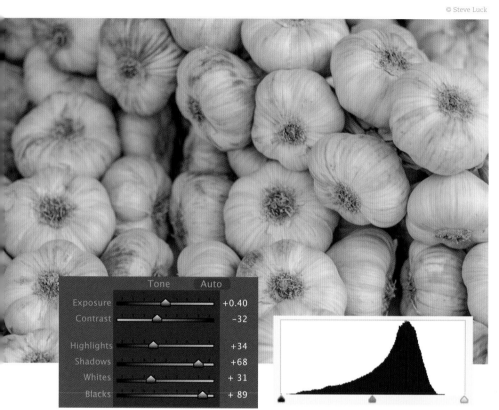

An alternative approach to seeking out strong graphical elements with distinctive line and shape is to look instead for the subtle nuances of form present in the objects that surround us. Although perhaps less immediately arresting than the high-contrast, high-impact approach that we looked at earlier, teasing out and exploring form can often create a more introspective mood that resonates longer.

Low contrast in nature, this type of imagery has a softer quality and is usually more suited to natural, organic objects rather than artificial ones, although this is by no means the rule. Lighting needs to be soft and diffuse, and although the specific direction

← Look first for the light

Some translucent sheeting helped to diffuse the sunlight that lay directly over a garlic seller's stall. The soft quality of the light helps to show off the organic, rounded form of the garlic bulbs.

Tone	Auto	
Exposure		+0.40
Contrast		−32
Highlights		+34
Shadows		+68
Whites		+ 31
Blacks		+ 89

↑↗ It's not all about high-contrast punch

When seeking to explore subtlety of form, a low-contrast approach often works best. It complements the soft nature of diffuse lighting and helps reinforce a gentle quality. Use controls that shorten the histogram (darken highlights and brighten shadows) so that neither the white point or black point are reached. This results in an image made up purely of a range of grays, with no black or white.

→ Follow the contours

This rocky outcrop was shot partly in shade and partly in direct sunlight. Notice how the juxtaposition of light and shade reduces in contrast from right to left, and how our visual awareness changes from the rock's outline to it's more rounded form as it does so.

© Steve Luck

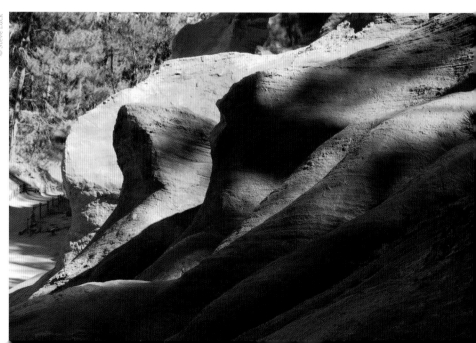

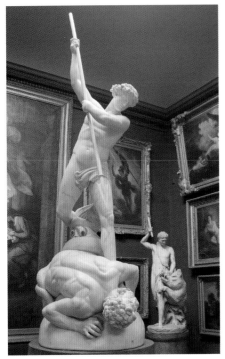

↑ **"St. Michael Overcoming Satan"**

Perhaps more than any other art form, sculpture, and more specifically classical and neoclassical sculpture, encourages an appreciation of the subtleties and nuances of form. This particular statue, by the Victorian sculpture John Flaxman, was lit directly from above through a skylight in the roof. This diffuse light shows off the human figures magnificently.

of light is not important, frontal or backlighting will fail to cast the soft, modeling shadows that are so useful when attempting to show off the three-dimensional quality of an object.

If you're photographing outdoors, avoid direct sunlight, as this may cast shadows that are too dark, and which may obscure the all-important detail and texture that often accompanies such images. We will look at this in more detail later. If indoors, again ensure lighting is soft and diffuse, and off to one side to help generate modeling shadows.

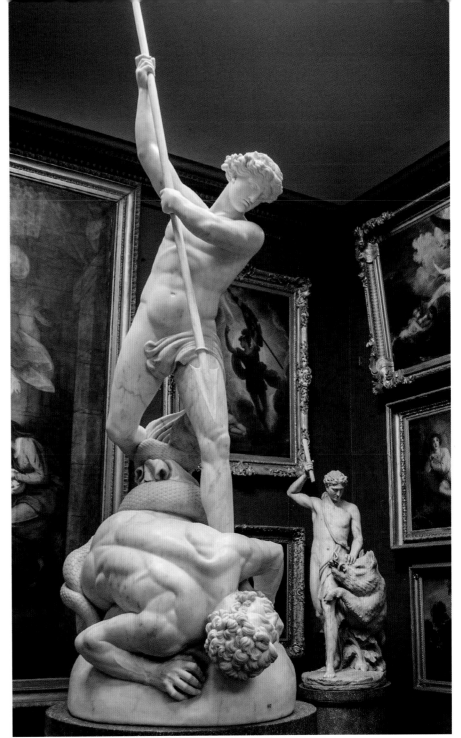

↑ **Sculpt with the light**

Of course, to apply a low-contrast approach in every case where you're looking to accentuate form would be a simplistic approach. The low-contrast version of this statue fails to deliver its inherent drama. Here, using controls to increase contrast and set the black and white points is more successful. The muscles are more clearly defined and the contrasting lighting brings much-needed energy.

High Key

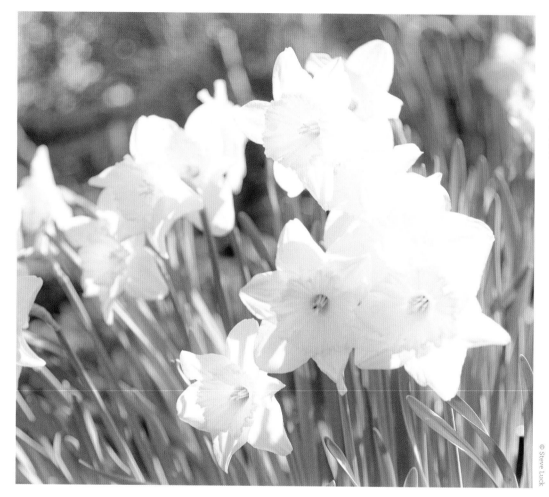

© Steve Luck

← **Appropriate subjects**
In a traditional high-key image, such as this shot of spring flowers, there are very few tones below middle gray—most of the image comprises of whites and light grays, but with so much delicate detail present, areas of pure white have been kept to a minimum.

High-key lighting was developed in the 1950s and '60s to overcome the inadequacies of movie and TV cameras, which were poor at capturing high-contrast tones. The intention was to light subjects evenly and brightly. The lighting technique, which eliminates almost all shadow, was adopted by stills photographers primarily for portrait and beauty photography. When shooting for a high-key portrait, ensure your subject is evenly lit, wearing light clothing, and is placed in front of a white or light-colored background. Aim to overexpose the image by around one stop (this applies to studio as well as outdoor photography) to achieve the light, airy quality that is a fundamental feature of high-key photography.

Traditionally, high-key images contain very few tones below middle gray. The tones should predominantly range from mid-gray to white, and subtle tonal gradation remains visible. This traditional approach to high key creates a delicate, ethereal quality. Recently, however, high key has also come to mean high contrast, in which the majority of the highlights are allowed to clip to white, contrasting strongly with a small dark, or even black, element. This extreme version of high key relies on well-defined line and shape to make the most of the graphic possibilities of such a treatment.

© Steve Luck

↑ Begin with brightness

The original unprocessed Raw file shows a brightly exposed portrait. The background is sufficiently light, and the only really dark tones are the girl's hair and eyes—ideal for high key.

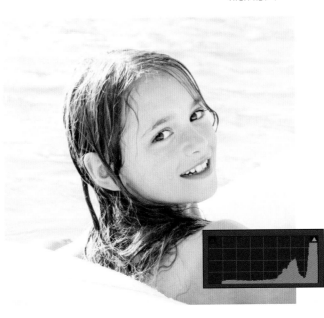

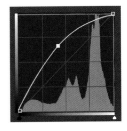

↑↑↗ Push it all to the right

To create a traditional black-and-white high-key version of the image, it's simply a case of adjusting the overall exposure so that the histogram shows increased highlights and a long tail of mid-tones and shadows.

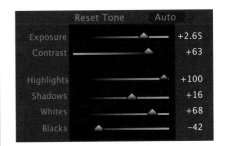

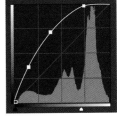

←↑ Almost-total loss of detail

A more contemporary approach to high key shows greater contrast with more of the highlights fading to detail-free white. Increasing the Contrast, and Highlights and Whites sliders achieves this. Add an additional highlight point in Curves and raise that for the same effect.

White & Bright

High-key black-and-white imagery, due to its light and bright characteristics, creates an uplifting, positive viewing experience, and has remained a popular monochromatic expression since it first appeared in the 1950s. For a high-key treatment look for images or scenes that contain no large shadows or dark regions, and if shooting for high key, aim to overexpose a little so that most of the detail is in the right half of the histogram. Having identified or captured a source image, the steps to a finished high-key image are straightforward.

↓ Light subject, no shadow
An ideal potential high-key image. There are no large shadow areas, clothing is light, and the subject of the image is perfectly suited to the atmosphere a high-key image creates. Additionally, there are a sufficient number of small dark areas, such as the eyes, to provide desirable contrast to the large pale areas.

© Suprijono Suharjoto

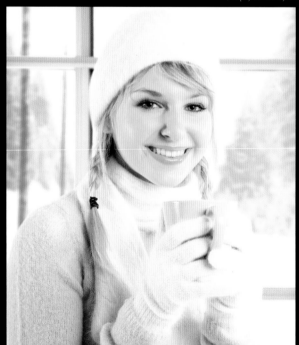

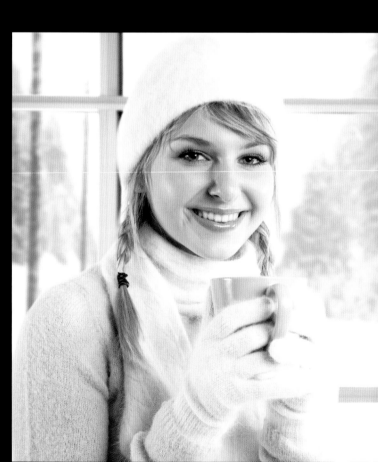

→ Auto is almost there
The default monochrome conversion provides a good starting point, as the color original image was close to high-key to start with.

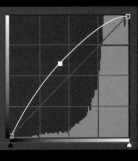

↑ Curves pull
The first step is to increase the brightness of the mid-tones using a Curves command. This lifts the skin tones and the woolen hat and gloves.

Challenge Checklist

→ Look for, or capture, a source image with few shadow areas, and aim to overexpose a little.

→ High-key images work best when there are at least a few dark tones to contrast with the mainly pale to white image.

→ Don't be afraid to clip the highlights for an extreme high-key treatment.

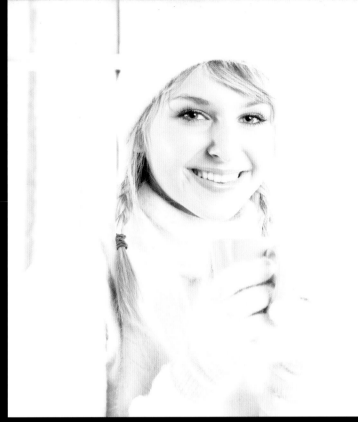

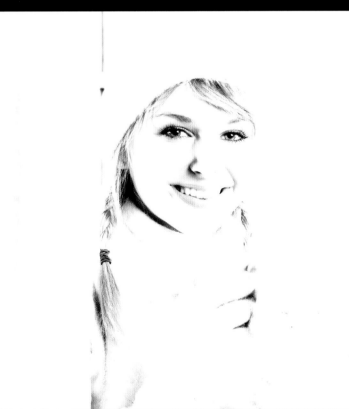

		Tint		Auto
Reds:				17
Yellows:				50
Greens:				23
Cyans:				203
Blues:				191
Magentas:				54

←↑ Local adjustments
Next, we can target the light-blue sweater and the gray-blue trees in the background by increasing the Cyans and Blues sliders. The result is a standard high-key image.

←↓ Pushed to the extreme
To create an extreme high-key image simply use a Levels of Curves command to clip some of the highlights to pure white, while at the same time darkening the few shadow regions. This intensifies the graphic quality of the high-key treatment, but makes the image harder to read.

Review

© Josh Ryken

This photo was taken in the corner of two windows, with a bit of fill flash, so it has few shadows. Overexposed a bit, it becomes a bright, dramatic high-key image.
Josh Ryken

The fill flash helps by not only making the skin tones lighter, but also adding a catchlight to the eyes. The eyes naturally attract our attention first, but then the density of the camera takes the view down to it. I assume you wanted the image to read in this way—first eyes, then camera—and that you kept the camera dark for that reason. The upper bars of the window strengthen the top framing, though it would also work if the image were cropped down from the top to make an all-white surround.
Michael Freeman

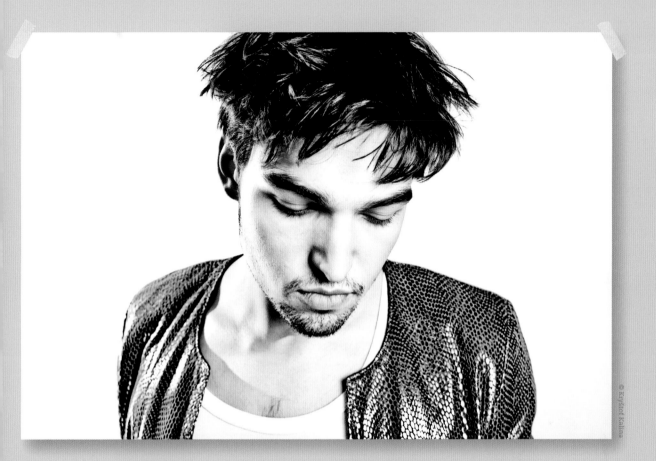

© Kryštof Kalina

This portrait of singer Jordan Haj tries to embrace a literal black-and-white style by suppressing all the grays. Such an approach is appropriate, I think, for the singer's youth and origins in post-communist Czech Republic and ever-restless Israel.
Kryštof Kalina

Excellent portrait, very well lit, and one that manages to combine two seeming opposites—the natural, youthful, aggressive, and rebellious feel with the subject leaning forward to the camera and shot with an angular, sharply cropped framing, yet at the same time a vulnerable, passive note from the downturn of the head and the gaze downwards. The high-key and high-contrast lightning and processing contribute very much to the former, and you've successfully held the skin tones bright yet unclipped.
Michael Freeman

Low Key

Just as high-key images are predominantly made up of light tones, so low-key images comprise primarily of dark tones. The mood is somber and forbidding. And as with high-key images, contrast varies depending on the subject and the effect you're looking to achieve. Stormy landscapes often make for powerful low-key images, and while it's fine to have areas of rich detail-free black, this type of low-key image has greater impact if shadow detail is still clearly defined. Having said that, however, in some circumstances allowing areas of unwanted detail—such as street signs or markings, billboards, and so on—to become black is an effective way of disguising such elements and creating a simplified, clutter-free image.

For successful low-key portraits you need dark clothing, a dark setting, and few, ideally well-organized, highlights. Whether lighting is soft and diffused or harsh and direct depends on the final look, but it should ideally be side lighting rather than frontal.

↓ **The Brutalist form**
The architecture of London's Queen Elizabeth Hall music venue makes for an excellent low-key subject. It was easy to ensure the concrete structure reproduced as dark gray, and the only major decision was how much to open the shadows—here opened up just enough to fully appreciate the Brutalist texture.

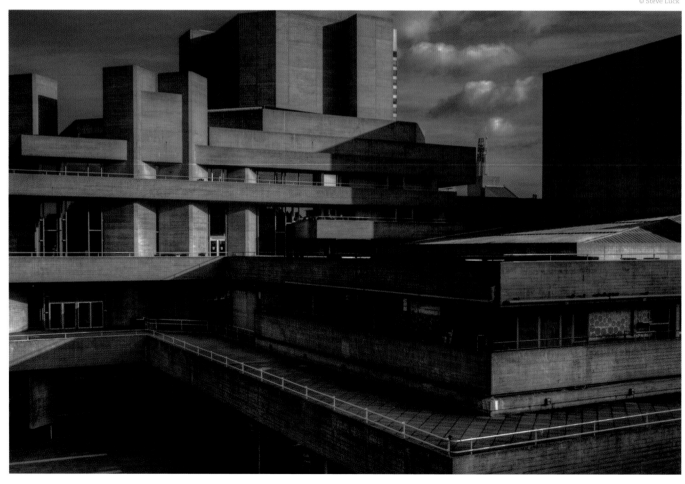

© Steve Luck

↑ A good candidate

This portrait is dominated by dark tones, including the black walls, the dark suit and bench, and the guitar case, offset by the lighter tones of the white shirt, pale skin, and peeling paint.

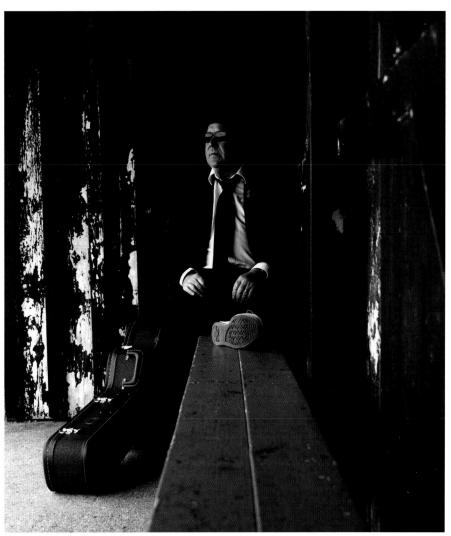

↑ Straightforward conversion

The default black-and-white conversion creates no surprises. The tones are much as we would expect them to be, but the image lacks real drama.

Tone		Auto
Exposure		−2.65
Contrast		+ 17
Highlights		+ 19
Shadows		+ 10
Whites		+ 53
Blacks		− 91

←↖↑ Pulled to the left

Reducing the brightness of the mid-tones, while holding the highlights using the relevant Raw conversion sliders or a Curves adjustment, creates an effective low-key portrait. The overall tone is dark, with a good distribution of pale tones, with light-toned facial features that appear out of a black ground.

Rich & Dark

↓ Start with the right tone
This essentially dark image has the right tones and subject matter for a low-key treatment. Our intention will be to let much of the image go to pure black, but hold detail in the man's face, hands, some of his clothing, and the background to retain the context of the shot.

As high key is seen as bright and uplifting, low key is usually considered sombre; and just as high key is comprised primarily of light tones, so low-key images are overridingly dark. Ideal candidates for a low-key treatment are images or scenes in which shadows dominate, but where a

small highlight area offers some contrast. The main controls for creating a low-key image are those that affect brightness, such as Levels or Curves, but by all means use the black-and-white conversion color sliders if you need to darken specific hues.

© Viktor Kuryan

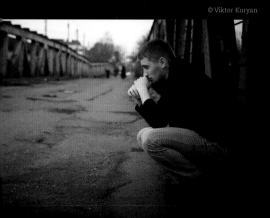

Reds: 40

Yellows: 60

Greens: 40

Cyans: 60

Blues: 20

Magentas: 80

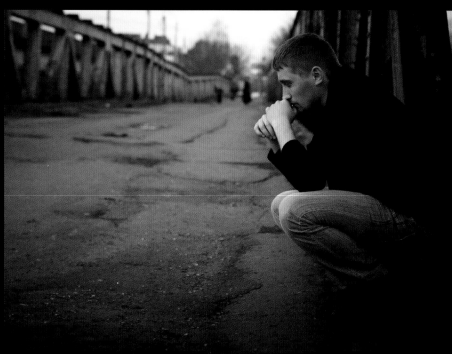

←↑ Step one
The default black-and-white conversion.

→ Step two

As I want to hold the detail in the man's face and hands and some of his clothing, I've made a quick selection around his body, heavily feathered the selection, then inverted it so that it acts like a mask.

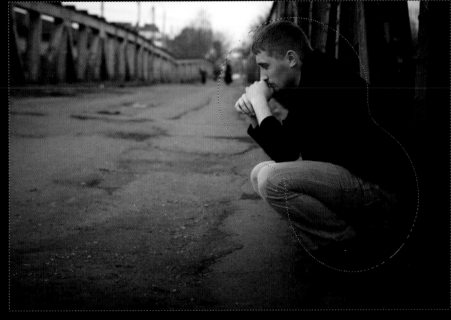

↓↘ Finishing touches

Next, using a Levels adjustment layer, I can clip the shadows so that they become pure black. Here, I've also darkened the mid-tones by around the same amount so that there is sufficient shadow detail in places to show the setting. The man's face and hands remain visible thanks to the mask selection.

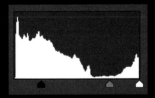

Challenge Checklist

→ Look for images or scenes that are predominantly dark; ideally there should be some highlights acting as a visual contrast.

→ Ensure the subject is appropriate for a low-key treatment.

→ Be bold when clipping shadows and mid-tones.

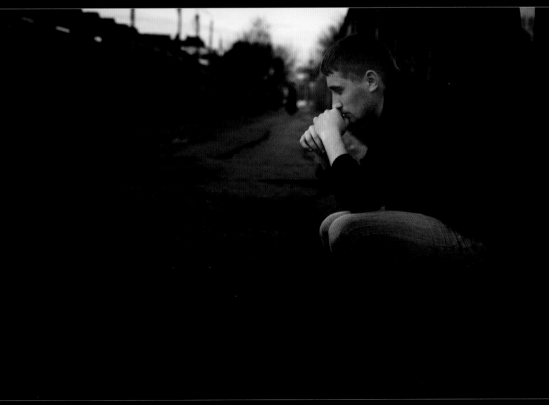

Review

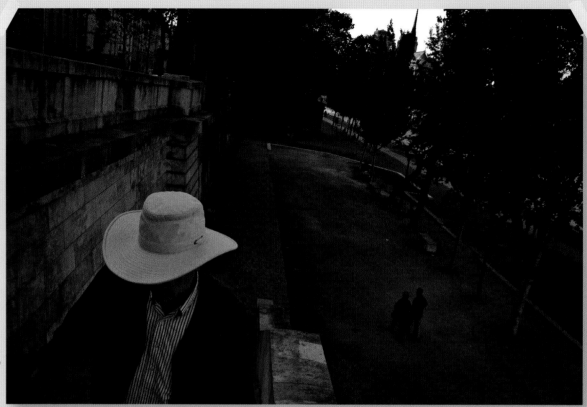

© Benoît Auguste

I noticed a guy with a cowboy hat, so I went down the stairs for the out-of-context subject. A wide angle offers plenty of context but meant getting very close. I took it blind, i.e., without looking through the viewfinder. In post-production, I kept the exposure intentionally dark to preserve the end-of-day feeling.

Benoît Auguste

An intriguing scene, full of questions—a hat like this in Paris? Who is he? His position in the frame and concealed face invite conjecture, and by printing down to keep the tonal range in the low end of the grays you add to the questioning mood. This was your motivation for the shot, and what a bonus that two figures way below are heading in the opposite direction. I have to admire your skill at blind shooting—you could hardly have framed better if you had your eye to the viewfinder and more time.

Michael Freeman

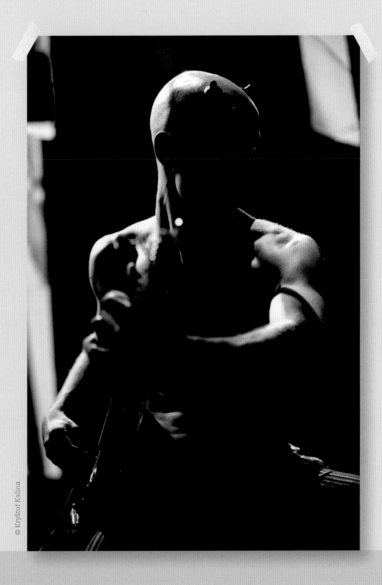

© Kryštof Kalina

Concerts of performer Bedrich Levý are known for their cabaret feel. It is the time when you ignore norms of your genre and just go with the flow. His face is known and therefore you aim for the character he is in. While shooting a gig at a smaller venue, you might be often confronted with very low-light situations. Instead of fighting it with skills and gear, I chose to accentuate it with an underexposure as that was my interpretation of the moment.

Kryštof Kalina

Good choice treating the bright outline of shaven head, shoulders, and arm as the key tones and letting the forward area fall into shadow—not least because of the musicians horns, which catch the eye all the more prominently for being on the shadow borderline of the skull, letting us read whatever we want into the scene.

Michael Freeman

Texture

Identified earlier in the chapter as a key compositional tool in black-and-white imagery (although one that is often overlooked), texture informs us as to how an object feels—rough and gritty or smooth and polished. In this way, texture complements and adds to our visual perception of form, albeit at a much smaller scale.

The significance of texture, as with form, is enhanced in black and white due to the absence of potentially distracting color; it's therefore important when texture is a key compositional element that it is shot under the optimal lighting conditions.

If your sole aim is to emphasize a rough, complex surface, look for a direct, bright, oblique light source that reveals, through shadow, all the tiny pits, grooves, peaks, and troughs you're aiming to highlight. For smoother, glossier surfaces a softer, more diffuse lighting is likely to yield better results.

It's important to bear in mind, however, that capturing texture alone is unlikely to create a composition with any lasting impact. Texture should be used to enhance our sense and understanding of an object's form, in which case any choice of lighting needs to take into account other compositional considerations as well as that of texture.

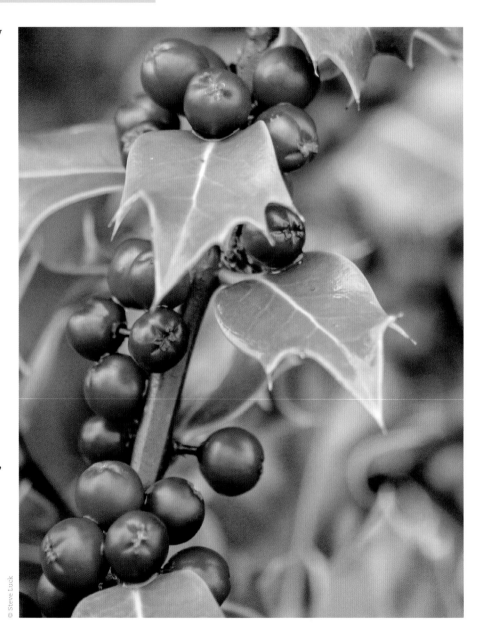

© Steve Luck

↑ **Diffuse light for textural emphasis**

For this study of holly, its leaves, and berries, the soft diffuse lighting of an overcast day reveals the waxy texture of the leaves, while at the same time helping to emphasize the spherical form of the berries. Strong direct lighting here would have simply cast too many distracting, dark shadows that would have failed to highlight the texture. In post-production, the valid aim was to lower contrast still further.

Curves adjustment

The rough iron and rivets of a ship's hull are highlighted by direct overhead lighting, which also casts the shadows that give the image some dynamic movement. Using contrast-enhancing controls in the form of a Contrast slider or S-shape curve adjustment reinforces the sense of texture.

© Steve Luck

Form to the ethereal

Given the right lighting, even something as formless and insubstantial as smoke is imbued with a textural quality, which in this case contrasts with the more substantial water beneath. Again, increasing the contrast helped to make the most of the textures on show.

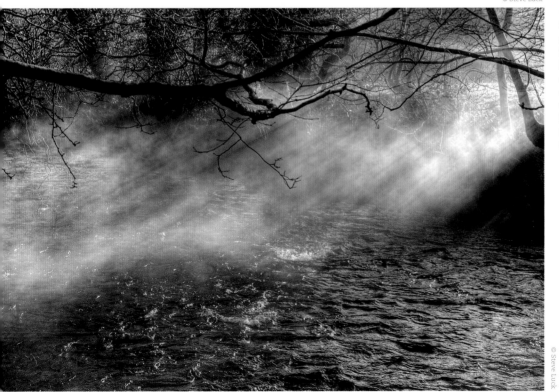

© Steve Luck

Mimicking Old Processes

© Steve Luck

As advances in photography, both film and digital, have brought us closer and closer to consistent and accurate color reproduction, it was inevitable that people would look beyond achieving naturalistic color in order to create images that stand out.

In terms of color imagery, many digital photographers have turned to emulating the highly stylized cross-process look that was made popular in fashion photography in the 1960s, and many of those interested in black-and-white photography have reacted in a similar way by creating images that have the appearance of film of days gone by—grainy and highly contrasting being a favorite.

Software manufacturers, most notably Nik in their Silver Efex program, have created a number of black-and-white presets, some of which attempt to emulate the look of certain types of film. Although this helps to ensure a consistent "one-button" black-and-white conversion, it's a relatively simple process to achieve the same result using image-editing software; and in the case of multiple images, recording an action to that the same process can be applied to any number of files with ease.

→ Agfa APX 400

This hurriedly taken street photo of a replica watch vendor was processed using Nik Silver Efex's setting of the iconic Agfa 400 film. The high contrast and grain are an accurate representation.

	Neutral
ISO 32	Kodak ISO 32 Panatomic X
ISO 50	Ilford PAN f Plus 50
ISO 100	Agfa APX Pro 100
	Fuji Neopan ACROS 100
	Ilford Delta 100 Pro
	Kodak 100 TMAX Pro
ISO 125	Ilford FP4 Plus 125
	Kodak Plus-X 125PX Pro
ISO 400	Agfa APX 400
	Ilford Delta 400 Pro
	Ilford HP5 Plus 400
	Ilford XP2 Super 400
	Kodak 400 IMAX Pro
	Kodak BW 400CN Pro
	Kodak Tri-X400IX Pro
ISO 1600	Fuji Neopan Pro 1600
ISO 3200	Ilford Delta 3200 Pro
	Kodak P3200 IMAX Pro
Custom	Custom

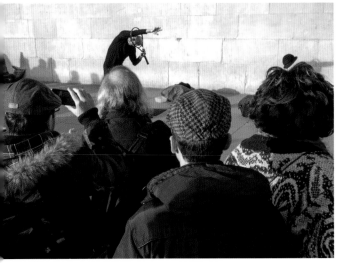

© Steve Luck

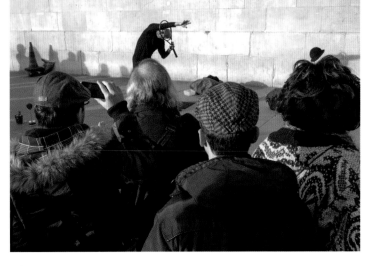

↑ Manual mimicking technique
Creating a grainy image in Lightroom that mimics fast black-and-white film is simple.

↑ Step one
The default black-and-white conversion.

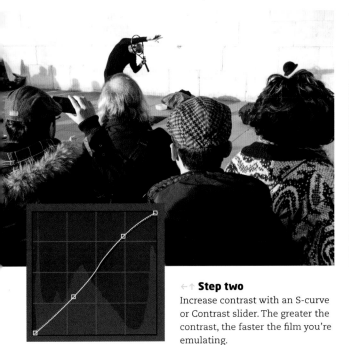

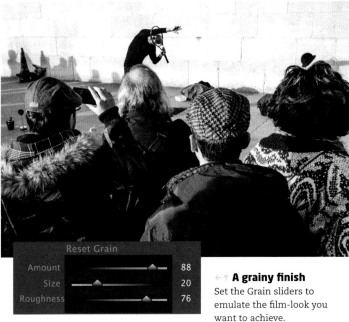

←↑ Step two
Increase contrast with an S-curve or Contrast slider. The greater the contrast, the faster the film you're emulating.

←↑ A grainy finish
Set the Grain sliders to emulate the film-look you want to achieve.

→ Alternate techniques
You can create a similar effect in pixel-editing software such as Photoshop or Photoshop Elements using the Noise filter. However, apply the filter to a new gray layer set to Overlay rather than the original image, then blur the filter slightly for a more realistic result. Experiment with the various settings and opacity to fine-tune the grain.

Old Style

Choice of subject matter is often the most crucial aspect when attempting to recreate a high-contrast, grainy "old style" image. Reportage or street photos will usually make good subjects—with grain (suggestive of fast film) helping to reinforce the sense of an image grabbed in a hurry. Other good subjects include historic buildings. There are numerous ways to give an image an old-style makeover, but the method described here works with most editing software.

↓ **Modern classic**
Although not of significant age, the house and gardens in this shot make a suitable subject for an old-style treatment.

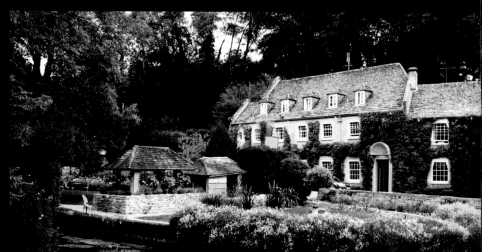

Challenge Checklist

→ An appropriate subject is key when applying a grain effect to an image.

→ Using layers and Smart Filters allows you to fine-tune the effect.

→ A sepia tone can help to reinforce the vintage look.

↓ → ↘ Grain and tint

To recreate authentic-looking grain add a new gray layer over the Black & White and Curves adjustment layers, and set the blending mode to Overlay. Right-click on the new layer to select Convert to Smart Object. Next, add uniform noise at 400% as a Smart Filter (which allows you to adjust settings at any time during the editing), then add a Gaussian Blur smart filter. Choose a Radius setting that creates an appropriate grain effect for your particular image. How the grain effect appears can be affected by the resolution of the image. To complete this particular example I added a sepia tint using the procedure explained on page 31.

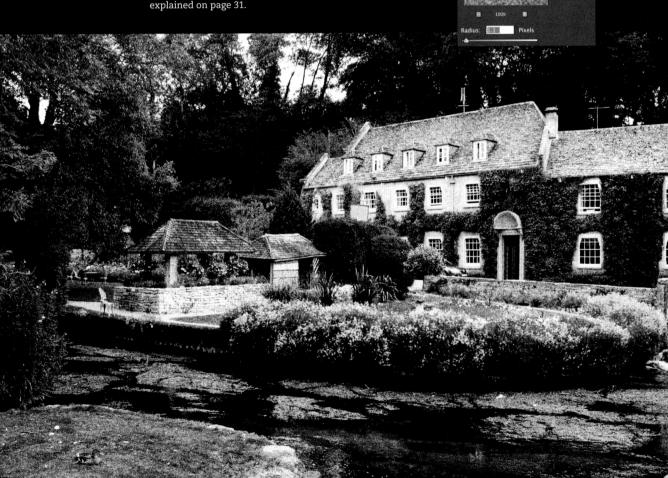

Review

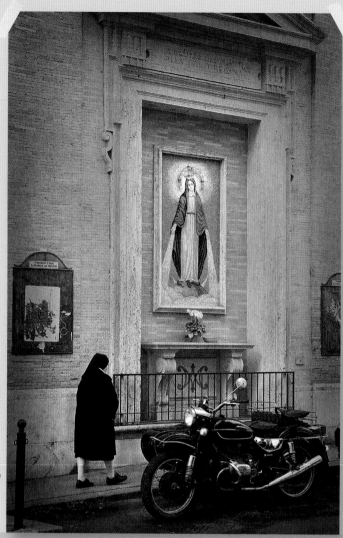

© Benoît Auguste

I took this shot because I liked the contrast of the nun and altarpiece with the motorcycle, and the content seemed suited to an old-fashioned B&W conversion. On top of the B&W layer I added two filters, one a brown color and the other a fiber one, for texture.
Benoît Auguste

Yes, you went for the triangle of interest (dare I say trinity?), with the added value of nun and motorcycle heading in opposite directions. Timing on nun perfect, by the way. The sepia tone adds a pleasant air to the proceedings, and possibly some sense of the antique. On the more general subject of antique-ing photographs like this, I've done it myself very occasionally, but find that it's best when used sparingly as in this book. Just three images out of many.
Michael Freeman

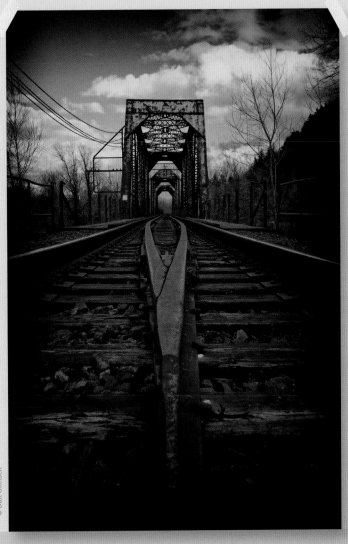

© Dan Goetsch

While in a small town in Oregon, I noticed this great railroad bridge that went over a river. I used the Live View function of my camera so I could position it very low to get the leading lines in the image. Once I got home and was going through them I liked this image but it felt like it was missing something. It had lost the old and rustic feel of actually being there. I used Nik Silver Efex Pro and added a sepia filter to the photo along with a vignette to shift the focus toward the center.

Dan Goetsch

The camera angle is indeed strong, and very precise (what would we do without Live View in situations like this? Answer: get clothes very dirty). If it were its original blue, that sky would be badly distracting, taking attention away from the rails and sleepers. Logic is definitely on your side for choosing sepia.

Michael Freeman

When to Choose Black & White

Following on from the previous chapter, in which we examined the tradition and history of black-and-white photography and explored the artistic styles and approaches that have evolved through an exploration of the medium, in this section we look at when monochrome might be preferred over color. In many cases this could be simply to emphasize one or more compositional elements without the distraction of color, but in other cases there are certain practical benefits of foregoing color. As black and white has its own distinctive and separate "reality," we are less rigidly bound to the "rules" of exposure that govern the vast majority of color imagery. And we can use this to our advantage. While featureless, white, blown highlights are to be avoided at all costs in most color images, for example, in black and white they are much less of an issue; and the same holds true for clipped shadows. There are also many other scenarios in which color can detract from the principal essence or subject of a photo—ugly casts or clashing colors, for example.

Natural Subjects

For the generation of readers who grew up in the 1950s and to a certain extent the 1960s, and for whom black-and-white photography was the norm, the question of which subjects lend themselves to monochrome is likely to elicit a different response compared with later generations, who tend to perceive black and white as inhabiting the realm of "art" photography.

For for the former, almost any subject in which color doesn't play a significant compositional role will lend itself to black and white; for later generations, we need to cast our minds back to the previous section and think about subjects in which the compositional tools of light, shade, texture, line, pattern, balance, and so on, are brought to the fore by the photographer, and in which the subject matter is almost incidental. In other words, without wanting to generalize, for some black-and-white photography means capturing the everyday in a medium that cuts through the sometimes distracting element of color—of which reportage and street photography are two examples—while for others black and white means creating artwork that reveals a photographer's unique sense of vision by emphasizing the basic elements of composition in the scenes and objects that surround us.

As we shall go on to see later in this section, there are also a number of practical reasons why a certain scene or image will look better in black and white than in color, but for now let's look at some individual examples that illustrate what's under discussion here.

© Steve Luck

↑ Natural tones

Although a color version of this image, if processed sympathetically—that is with a subdued color palette—would work well, the monochrome treatment encourages the viewer to look beyond the misty autumnal woodland scene, and explore the image for its range of tones, its numerous textures, and the lines and forms present.

← Follow the lines

The line of a coastal defence wall and associated steps provide a perfect vanishing-point composition. Such a contrived viewpoint complements the black-and-white treatment as both take the viewer one step farther from the reality of the scene and help to emphasize its inherent geometry. Compositions with strong lines—whether verticals, diagonals, horizontals, or a mix—often make powerful black-and-white images.

↑ Form first

Flowers are justifiably notable for their subtle color ranges and not often considered candidates for black and white, yet when portrayed as such without color to distract us, we can appreciate them all the more for their delicate and repeating forms, and subtlety of hue is successfully replaced by one of tone.

↑ Traditional areas of black-and-white style

Not all black-and-white images aim to seek out and emphasize the generally recognized elements of composition discussed here. Portrait photography, reportage, and street photography all have strong B&W representation; the reason behind such treatment in these genres lies in the attitude that color can be an unnecessary distraction that gets in the way of the "meaning" of a photograph.

Harsh Light

As we've seen, there are numerous aesthetic reasons for wanting to display an image in black and white, and most of these are concerned with placing emphasis on one or more aspects of composition. But there are also a number of practical reasons why an image, which is unsuccessful in color, might become viable when converted to black and white.

As we saw in the previous section, black and white permits the photographer to experiment much more freely with extremes of light than in color imagery—the absence of color, for example, allows areas of an image to clip either to black or, more significantly, to white without necessarily detracting from the image. It goes without saying that much of this depends on the content and composition of the image, but the principle is that with some images there's little to fear if even relatively large areas of the image are pure white or pure black when converted to monochrome.

In many cases, thanks to data-packed Raw image files and powerful Raw editing and post-production software, it's now possible to retrieve seemingly lost detail, and for example, to hold highlights while brightening shadows. This flexibility allows us to extract the maximum level of detail in our images. But no matter how large the image files or how good the software, if detail is never recorded (due to extremely bright conditions, for example), or you only have an 8-bit JPEG to work on, converting to monochrome is often the best way of creating a usable image.

© Steve Luck

← ↓ Hotspots
Harsh midday sun is possibly the worst lighting for capturing portraits—strong shadows are interspersed with extremely bright highlights. Often, areas of skin that are exposed to direct sunlight will overexpose to create detail-free "hotspots," as here around the subject's nose. Shot as a JPEG, there's little that can be done in post-production. Although it can't bring back detail, converting to black and white does play down the progression of pale reddish skin to white, by removing the hue so that the fade to overexposure is one of just tone, rather than tone and hue.

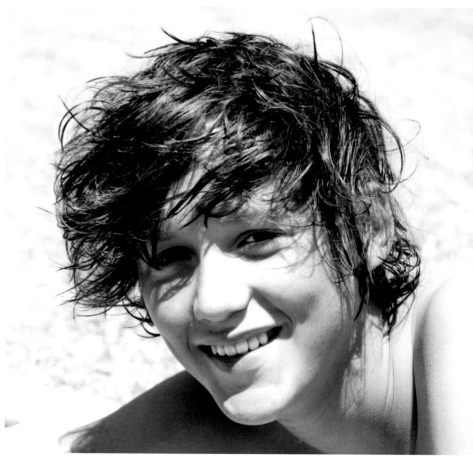

© Steve Luck

↑→ Fixing blown highlights

Another case of harsh bright light. In this instance the small area of sky and the bright white canopy have totally blown. The white lettering and logo on the umbrella have also been rendered almost invisible, as they're reversing out of a bright yellow. A monochrome conversion minimizes the effect of the blown highlights, and the lettering and logo are legible.

© Steve Luck

←← Pure-white skies

Shooting backlit objects will often result in an overexposed background. While in a color version the blown background leaps out at the viewer, in the black-and-white version it's less noticeable and helps to create a more graphic representation of the building.

Taking Graphic Opportunity

↓ Contre-jour shadows
Shooting into the sun has resulted in areas of the sky between the trees blowing out. As these areas are relatively small the image isn't a disaster, but it may work better as a graphic black-and-white photo.

No matter how good your camera's dynamic range response or how careful you are when setting the exposure, there are bound to be times when it's simply not possible to capture the full range of tones in a scene. A common high-contrast scenario is shooting into or toward the sun. Unless you're prepared for the subject to become a featureless silhouette, then it's likely that you'll have to live with an overexposed sun and sky. Depending on how much of the sun and sky are visible, this may or may not be acceptable in a color image.

Reds:	40
Yellows:	60
Greens:	40
Cyans:	60
Blues:	20
Magentas:	80

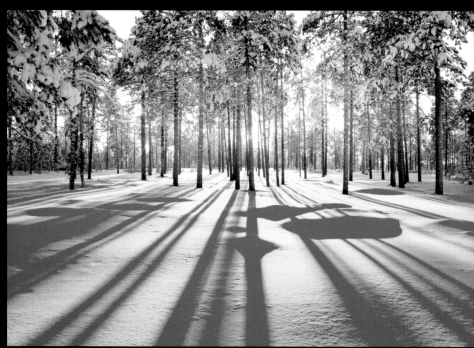

←↑ A promising start
The default black-and-white version shows potential. The once blue-black shadows contrast powerfully with the white snow, as do the dark trees against the pale sky.

Challenge Checklist

→ Don't avoid capturing a high-contrast scene just because highlights are overexposing. A contrasty black-and-white version can create a dramatic graphic image.

→ Look for close juxtaposition of highlights and shadows to emphasize contrast.

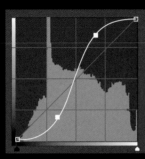

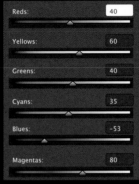

Reds:	40
Yellows:	60
Greens:	40
Cyans:	35
Blues:	-53
Magentas:	80

←↓ Contrast in Curves

A steep S-curve creates much more contrast and certainly adds to the drama and graphic nature of the image. Darkening the blue tones helps darken the shadows and the foliage of the trees. The blown out highlights, rather than detracting from the image, now provide a clean background for the dark tree trunks.

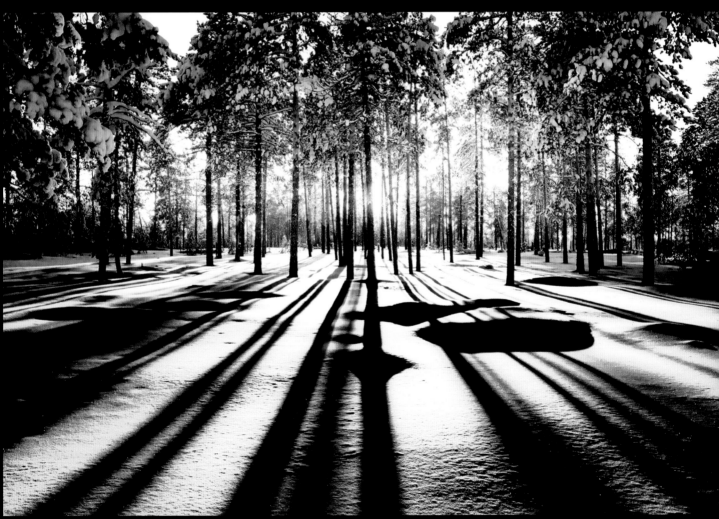

Review

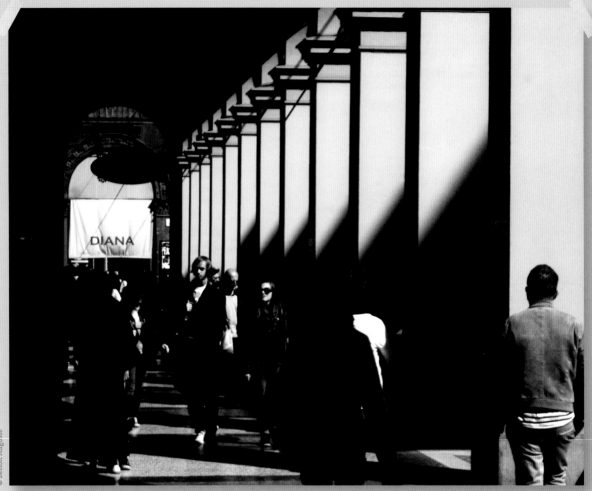

© Benoît Auguste

Combining long shadows cast by a setting sun with stately architecture all but guarantees interesting shots. This one I liked because of the repeating patterns receding into the distance, following the crowd. B&W conversion was simple, as I simply cranked up the contrast to emphasize the graphics over the literal content.
Benoît Auguste

As you note, this is all about the repeating shards of light, the slightly soft-edged shadows each fingering a passer-by. Quite rightly, you strengthened the contrast to play to this idea. So far, so good, but I'd suggest that the losers in this have been the shadow-lit passers-by, and the people are one half of your declared story. If you went back into the processing and worked locally, I suspect you might be able to pull out at least three figures lost in shadow and bring them back into the graphic action.
Michael Freeman

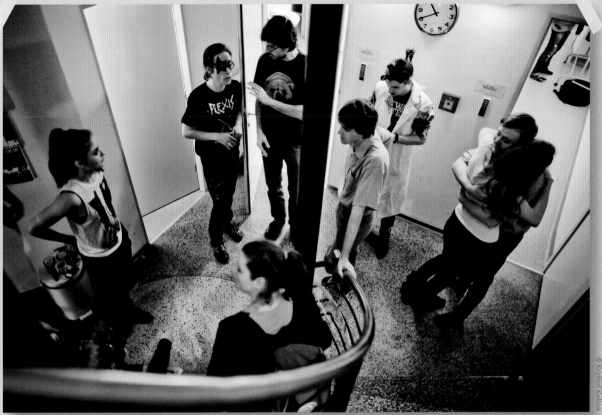

© Kryštof Kalina

Here a director gives notes to his cast just after a show—a moment you shouldn't disturb, but definitely want to capture. A lot of emotions were in the air. I've tried to distract the eye of the viewer with available graphic elements (namely, the lines of the staircase pulling attention in), while being respectful of the emotions.
Kryštof Kalina

Interesting that you say you used the lines to distract the viewer's attention, when my first and lasting impression is that you used the curved line of the bannister and the downward-converging other lines to enclose and contain the eight figures very neatly. I don't doubt your intention for one minute, but the picture works well for me precisely because you organized it at a moment's notice. This leaves the viewers to examine at leisure the different little scenes being played out within the divided spaces.
Michael Freeman

Strange Light

Another reason for attempting a monochrome conversion due to issues with light is less to do with contrasting extremes and more to do with its color.

In most cases, fixing color casts caused by different color temperatures, such as the warm red tones of domestic tungsten lighting or the pale oranges or greens of some street lights, is relatively straightforward in editing software, particularly if the original image was shot in Raw.

Yet, there are times when the lighting has such a strange color cast that, no matter how you try to fix it in post-production, it just seems to look wrong. Often, this is down to a mixture of different light sources, such as tungsten with fluorescent, but occasionally it can also be to do with the colors of other elements in the images, such as floors and walls, or even skin tones. In such cases, you either have to decide which element of the image you want to look right, or alternatively, take hue out of the equation altogether and go for a monochrome conversion.

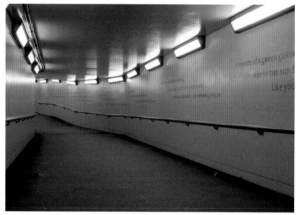

Auto white balance

© Steve Luck

"Corrected" white balance

←↖↑ Avoid impossible color adjustments
The walls of this London underpass feature lines of poetry by the poet Sue Hubbard. The poem, "Eurydice," was commissioned especially to decorate the walkway. The color cast of the street lighting combined with the color of the walls created an unpleasant green glow when captured by an Auto white balance setting. And although Raw conversion allows you to set any white balance after the event, the "correct" adjustment resulted in pale blue walls that seemed incongruous with the gravitas of the poem. A black-and-white version avoids the color cast issue and does away with the insipid blue.

↑ → ↘ Simplifying flare fixes

This photograph of worshippers leaving church was shot partly into the sun, resulting in bad lens flare, featuring a variety of colors. A default black-and-white conversion instantly deals with the issue of discoloration, leaving a much more straightforward editing job to get to a usable image.

Strange-colored light effects can also be caused by imperfections in camera equipment. Lens flare, for example, as well as creating the familiar polygonal shapes, can also result in areas of strong discoloration, as can light leakage, in which the sensor or film is exposed to extra light entering through the camera body.

These issues are notoriously difficult to fix using standard cloning tools, but rather than discard the image, a black-and-white treatment will often minimize the discoloration effect, and give the photographer an image that may be easier to improve.

Color Workaround

↓ Dismal artificial light
A typical shopping mall has a mix of lights of varying color temperatures, often making it impossible to set a "correct" white balance. The ugly color casts can detract from a potentially interesting shot.

Despite the level of control we now have over white balance settings both at the time of shooting and in Raw conversion, you may still encounter lighting setups that are so varied—a mix of fluorescent, halogen, and incandescent lighting, for example—that no matter how careful you are shooting a gray card or making adjustments at the Raw conversion stage you find it's impossible to capture a scene that shows neutral lighting. Shopping malls are a good example.

Depending on the size of the mall, you may find shop lighting competing with colorful signage, which in turn is competing with the mall's own lighting, all of which have very different color temperatures. One approach to avoid unpleasant-looking color casts in one or more areas of the image is to convert to black and white. From an initial conversion you may also have the option of exploiting any line, pattern, and shapes present.

Reds:	40
Yellows:	60
Greens:	40
Cyans:	60
Blues:	20
Magentas:	80

←↑ Starting point
By converting to black and white, the color cast problem is instantly resolved, and we can begin to see the potential of line and shape.

Pushing the highlights

By dispensing with the issue of color, we're free to try various approaches to make the most of the composition. One option is a light, "space-age," high-key approach created using a Curves command.

Challenge Checklist

→ If ugly color casts make an image harder to read, a black-and-white conversion can simplify an image.

→ Use Curves and Levels commands to emphasize key compositional elements.

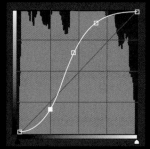

S-curve adjustment

Also using curves, an alternative approach is to aim for greater contrast to emphasize the leading lines of the moving stairways.

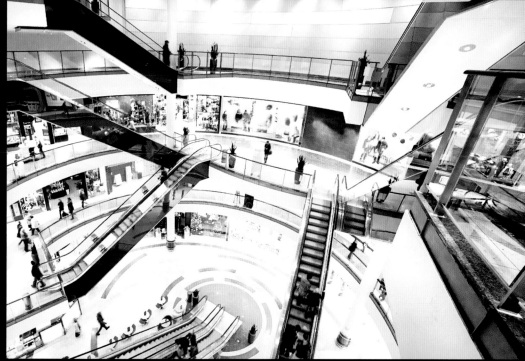

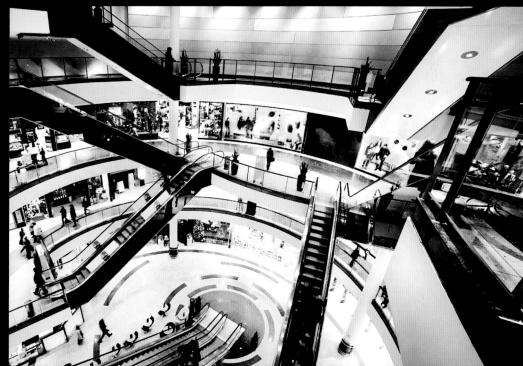

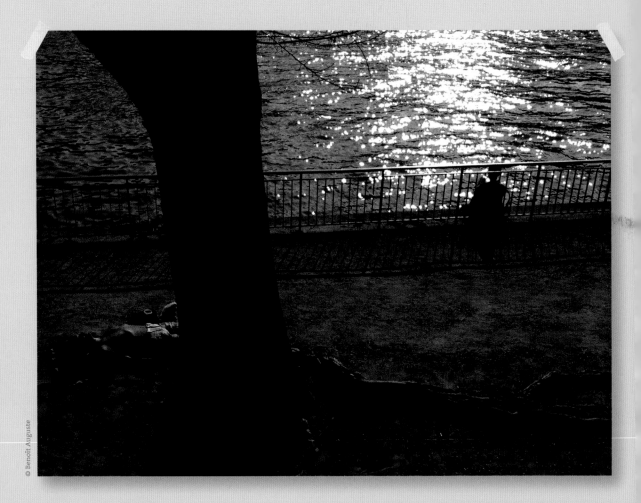

© Benoît Auguste

This summery Seine scene had a great composition and tonality, but the color temperature difference between the shade and the warm sun reflecting off the water meant either a lot of painstaking local adjustments, or a much more natural B&W conversion, which I think preserved the feel of the scene better anyway.
Benoît Auguste

Quite witty and strange, as some unknown species of half-man, half-root lounges behind a tree trunk. If this kind of visual pun is to work, it needs the viewer to come across it in the picture at a moderate pace rather than being slapped in the face at first glance. Hence, the dark gray tonality of this area, which we arrive at a little slowly, having first been caught by the glinting water and railings. Interesting that you worked with the sunlight-to-shade color temperature difference to control the tones carefully.
Michael Freeman

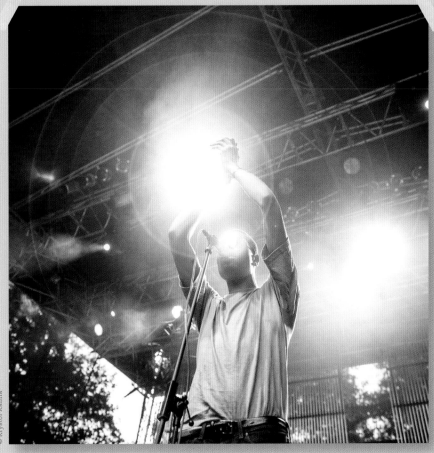

© Kryštof Kalina

Open-air festivals are a great opportunity for strong images, but always a huge challenge regarding your approach. This particular shot has obvious glare, but it works well to communicate the excitement and energy of the performance—but only in the B&W version. The color original simply looked washed out, with no differentiation between the performer and the surrounding light.

Kryštof Kalina

A perfect example of how B&W can accept almost any degree of exposure and contrast. You use the term "washed out," which if we think about it is only used for color photography. Black and white can escape this, so that here the flaring, blown-out lights have become magical orbs (not least, thanks to the concentric flare circles).

Michael Freeman

Distracting Colors

Even if colors aren't actually "wrong," as can be the case with most color casts or lens flare issues, there can be more subtle reasons for wanting to take color out of an image.

As you become more proficient at previsualizing and seeing in black and white before actually shooting, you'll begin to see how color can "get in the way" of a well composed image. We're so used to living and experiencing color, that often we might overlook a photographic opportunity because color has prevented us from seeing the potential in the scene.

If you're working retrospectively so to speak—shooting first and reviewing for black and white later—look through your images and deliberately seek out those that feature discordant colors, or one or two dominant colors that distract from other, potentially more important compositional elements, such as form, line, and texture, or which prevent the viewer from fully appreciating the subject of the image. Convert these to monochrome and, more often than not, you'll reveal a quality about the image that was not there in the color version.

The more familiar you become with monochrome imagery, the more likely it is that you'll begin to view color as often unnecessary and occasionally downright distracting.

←↓ Street scene
Our urban environments are packed with artificial color, from the clothes we wear to billboards, store windows, cars, and trucks. This mass of color can overwhelm the senses. Stripping color out of this particular street scene equalizes the jumbled tones and helps us to focus more on the three-way conversation that is the principal subject of the photo.

© Steve Luck

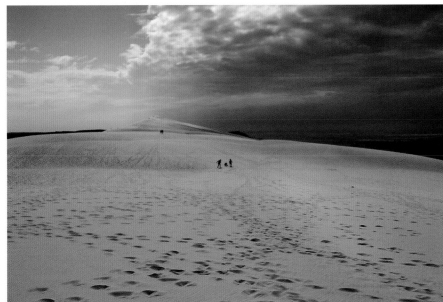

© Steve Luck

←↓ Dune of Pyla

Although orange and blue, the two principal colors in this image (of the largest sand dune in Europe, near Arcachon, northern France), are complementary, they don't add anything to the key intention of the image, which is to show the vast scale of the dune. The grayscale version is visually more unified, the tiny figures show up more clearly against the more neutrally rendered sand, and the blue-black clouds appear more threatening when presented as gray-black. All in all, the black-and-white version has greater presence and impact than the color one.

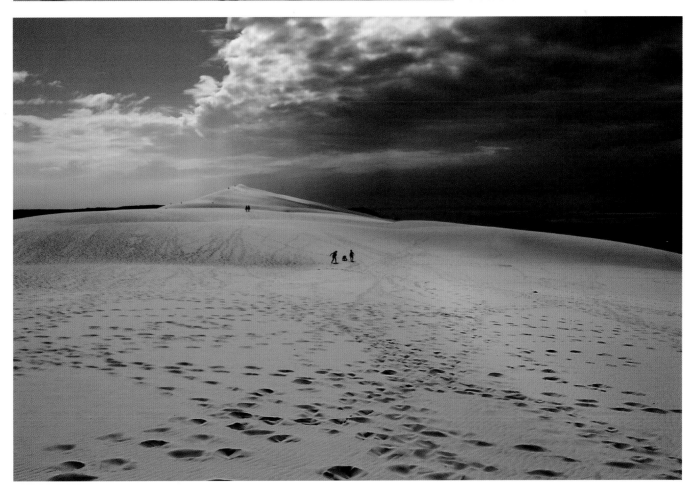

Shifting Visual Attention

As we've seen, color can distract from the fundamental essence of an image, and simply removing color can help the viewer gain a better understanding of what the photographer was trying to achieve. However, we can also use color channel information to manipulate the tones in an image so that the viewer's eye is drawn to one aspect or another, even when the image is converted to monochrome. To make this possible it's easier (and much quicker) if the elements you want to draw attention to or distract from are saturated.

↑ Colorful cacophony
This wonderful street shot has some great clashing colors, but they're fighting for our attention. A black-and-white treatment will allow us to draw attention to certain elements.

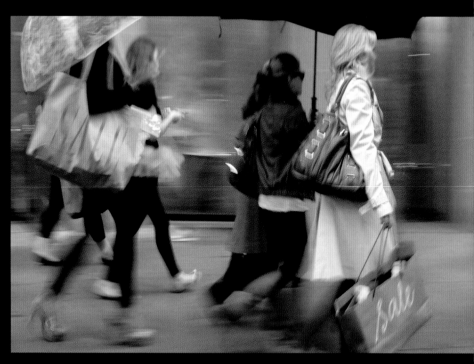

↑ Step one
The default conversion holds few surprises, and although perfectly acceptable, underplays the color contrast between the yellow shoes, and

Challenge Checklist

→ With saturated colors it's possible to draw attention to or distract attention from particular elements.

→ Use black-and-white conversion color sliders to brighten or darken specific elements.

→ With black and white it's possible to make greater tonal adjustments to emphasize elements than would be possible in color.

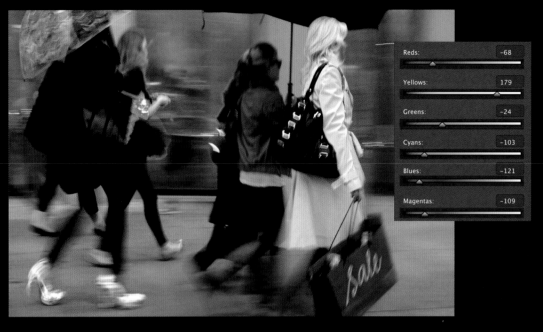

↑ Not quite there

With bright saturated colors to target, it's a simple job to attract attention to the shoes by increasing the Yellows slider while pulling back on the Magentas and Reds. So, although we now have a version that draws the viewer to the shoes, it's not perhaps representative of the original.

↑→ Lots of visual variety

Keeping the Yellows where they were and increasing the Reds and Magentas sliders brightens the bags and red coat. This final version is more successful at conveying the bright tones of the original, even though we can't distinguish between the yellows, pinks, and reds.

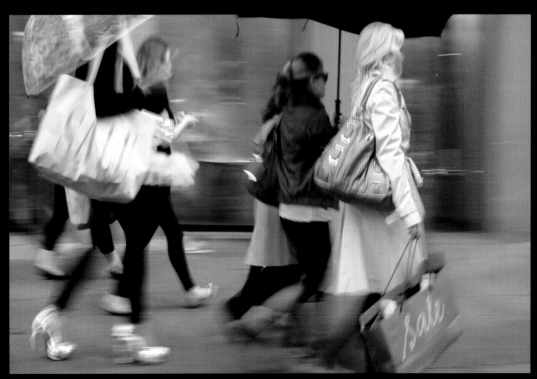

Review

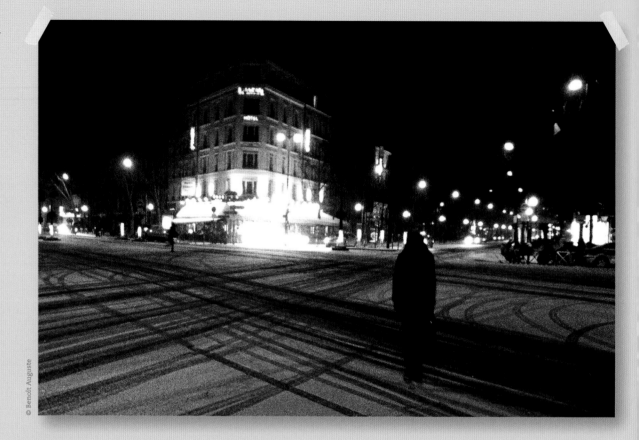

© Benoît Auguste

I knew when I took the shot that the main subject was the walking figure in the foreground, and I wanted to accent her solitude. So I selectively darkened her to pure black, which contrasted with the overexposed shop on the corner. Then I added a lot of grain in a separate filter to evoke a late-night feeling.

Benoît Auguste

In a high-contrast city night scene like this, something has to give, and if a key subject is in a darker area, then the highlights are going to blow. Here, B&W not only has the capacity to stay acceptable when highlights are clipped, but this bright street corner works all the more strongly as a picture element in its own right. I wonder, though, if it might not be worth some careful local increase in contrast around the figure, whose head and legs are merging with the backgrounds, to stand out a bit more distinctly.

Michael Freeman

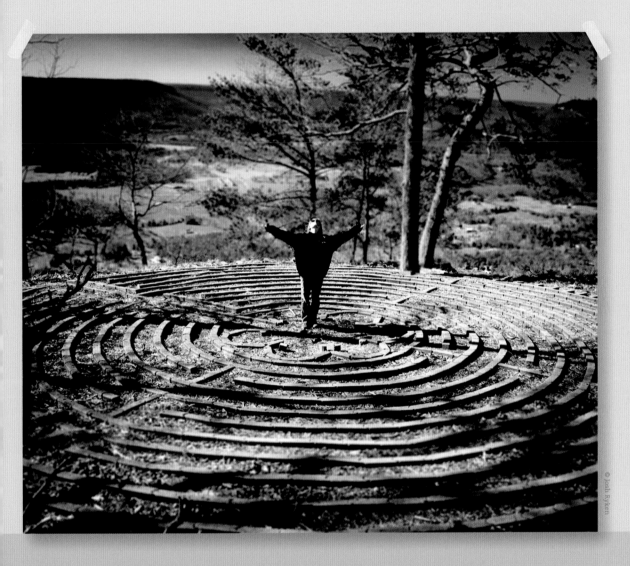

The eye is naturally drawn to the center of this image because of the concentric circles. However, I enhanced this effect by darkening the model's jacket through tonal adjustments, and brightening the ground around her.
Josh Ryken

Increasing local contrast is definitely the way to go when you need to emphasize an element in a picture, and the adjustment itself is not obvious—always a sign of careful processing. When darkening or lightening locally, it's easy to overdo it to the point of drawing attention to the process rather than the subject, and you carefully avoided that. I'd like to know more about the earth sculpture, though—if that's what it is.
Michael Freeman

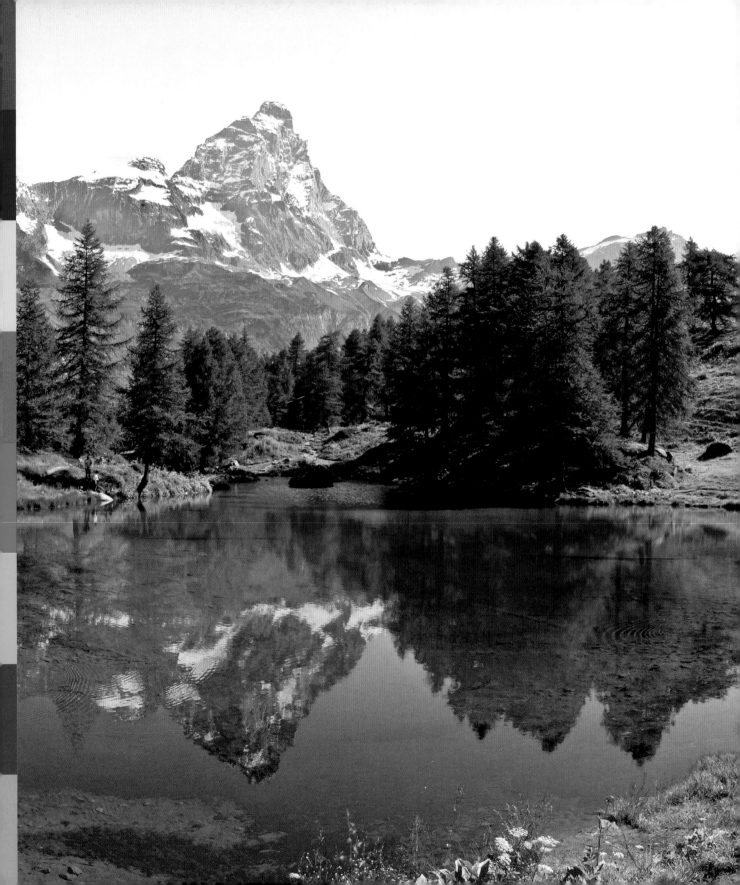

The Major Themes

Having learned earlier about the tools and techniques that afford us so much creative potential when converting from color to black and white, it's time to look more closely at specific scenarios in which we can make the most of what we've learned.

With so many controls at our fingertips, much of how we convert comes down to personal preference and matters of taste. However, as you work through these major themes and exercises it becomes apparent that, even with the absence of color, you'll often make black-and-white conversion adjustments that render an image unrealistic. In cases of portraits, for example, this is likely to be an issue, but in many other cases, again this is often a case of personal taste. Landscapes for example can be made to look realistic or surrealistic the choice is yours. Essentially what you should be aiming to achieve is to use monochrome conversion to highlight qualities of the image that are overshadowed or even lost entirely due to the presence of color.

Landscape

Ask a group of people, photographers and non-photographers alike, which principal genre of photography they'd least associate with black and white, and a good number will say landscape. Portrait, architecture, nude, art, street, reportage, fashion—all have a much greater monochrome presence today than landscape.

Ironic, therefore, that arguably the best-known photographer in the United States is Ansel Adams, who is famous for his black and white landscapes depicting the wilderness of US national parks.

Over the years we seem to have forgotten about the lengthy and illustrious history of black and white landscape photography. Indeed, along with portraits and street scenes, landscapes were a principal early photographic theme. The absence of color in the early days of photography, and right up to the 1950s and 1960s, did little to deter photographers from capturing the many and varied wonders that the natural world had to offer. Without having to consider color, photographers could concentrate on exploring the lines, forms, textures, and tones of the landscapes they encountered—indeed, it was exploration of tone that led Adams (along with his friend and associate Fred Archer) to devise a systematic approach to tonal analysis. The so-called Zone System was a fundamental aspect of Adams' concept of previsualization, in that it allowed the photographer to determine the tones that he or she felt were important in

© Steve Luck

any given scene and helped to ensure that the tonal distribution envisioned in the field could be accurately realized back in the darkroom through careful exposure and development control.

Naturally, the Zone System as conceived and devised by Adams and Archer has little bearing on modern digital imaging. This is partly because sensors respond very differently to film, and also because we have so much more control "after the event," particularly when shooting Raw. In addition to adjustment over exposure afforded by Raw-conversion software, in terms of grayscale, today's black-and-white conversion tools also allow

↑ Concentrate on composition, not color
Landscape photography today, perhaps more than any other genre, is closely wedded to color; and that's perfectly understandable, as color can be a powerful compositional tool. But it's also just one of many tools, and the danger is it can often supplant other forms of expression that are just as, if not more, powerful.

us to freely adjust tone by color range. No longer do we have to place one tone in one zone and live with the other tones falling naturally into their prescribed place one exposure stop above or below; we can squeeze and stretch tones, and determine the contrast of an image almost at will.

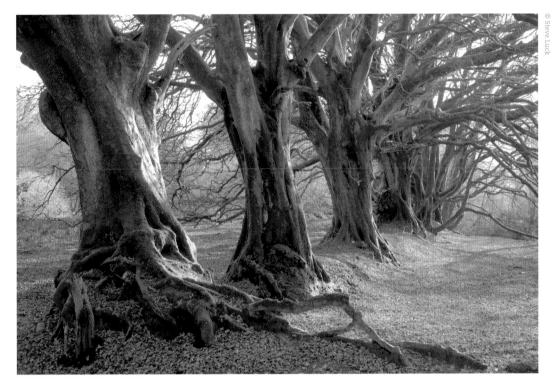

© Steve Luck

← The significant elements

For many photographers, not having to take color into consideration can be an enormous sense of relief. If the color in an image isn't contributing to a composition that you like for other reasons, such as for the texture, form, pattern, or light, you may find converting the image to monochrome helps bring out those other elements.

However, there are two important provisos: First, overmanipulation may well result in noticeable and undesirable artifacts; and second, there is the issue of creating images that look natural. The latter is akin to the debate over HDR. Some will object to too much manipulation on ethical grounds, while others may object for aesthetic reasons. There will also be a third group for which anything goes, arguing that black and white can't be realistic by its very nature, and that if one accepts the artificiality of low-key and high-key images then where can you draw a line of unacceptable behavior. Today, more than ever before, black-and-white imagery of whatever genre is about personal interpretation, and over the coming pages we'll see how image-editing tools can provide different interpretations of landscape scenes.

© Steve Luck

← Deliberate B&W

Intentionally going out to shoot in black and white, rather than converting color to black-and-white as a post-production decision, encourages you to look at nature and landscapes in a different way. You'll find that you'll be looking for specific qualities, rather than concentrating on the actual subject matter.

Tonal Style

In black-and-white editing there are two ways of controlling contrast. The first, perhaps more obvious method, utilizes tonal commands such as Levels or Curves to brighten highlights and darken shadows. The second method is to adjust the luminance values of specific color channels to darken or brighten the relevant tones. For example, a predominantly blue sky can be made to appear either very dark or quite light, thereby potentially increasing or decreasing contrast respectively.

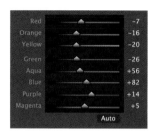

Red		−7
Orange		−16
Yellow		−20
Green		−26
Aqua		+56
Blue		+82
Purple		+14
Magenta		+5
	Auto	

↑→ **Brighter ocean**
In this black-and-white conversion, the Blue and Aqua sliders have been pushed up to near maximum, making the ocean pale. This contrasts less with the light cliffs and more with the darker grass.

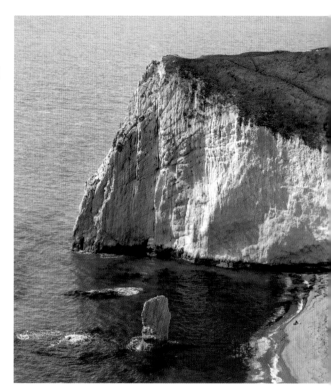

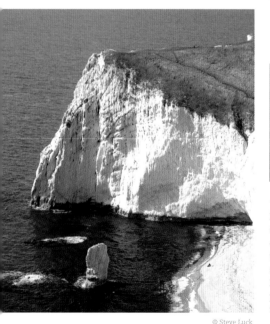

© Steve Luck

↑ **Natural contrast**
The white chalk cliffs of this stretch of the south coast of England contrast strongly against the blue sea.

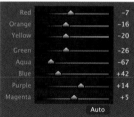

Red		−7
Orange		−16
Yellow		−20
Green		−26
Aqua		−67
Blue		+42
Purple		+14
Magenta		+5
	Auto	

↑→ **Darker ocean**
Reversing the Blue and Aqua sliders results in a much darker ocean. The color of the sea now contrasts more strongly with the white cliffs. Later, we can see how it's possible to alter vegetation for even greater impact.

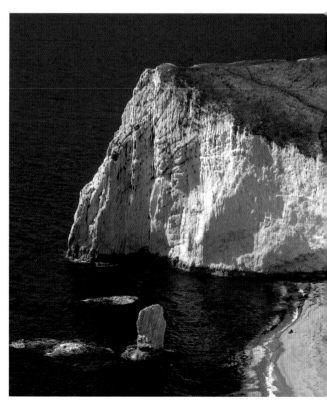

With so many powerful image-editing controls at our beck and call, it's possible to manipulate a landscape image either to emphasize contrast—which can often have the effect of compressing distance—or to broaden the tonal range, which helps to reinforce the distance between (usually darker) foreground elements and the (lighter) background.

The reason tonality plays such a significant role in our perception of distance is that it taps into our visual understanding that more distant objects appear less contrasting. A phenomenon known as aerial perspective, it's caused by the scattering of light, which visibly increases over distance.

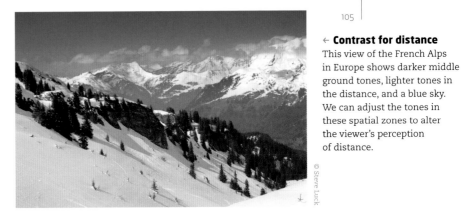

© Steve Luck

← **Contrast for distance**

This view of the French Alps in Europe shows darker middle ground tones, lighter tones in the distance, and a blue sky. We can adjust the tones in these spatial zones to alter the viewer's perception of distance.

← **Step one**

The default black-and-white conversion, as we'd expect, conveys a similar sense of distance with tonal values that reflect those of the color image.

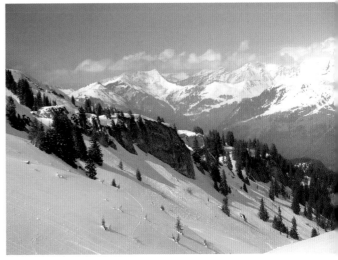

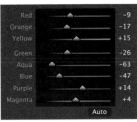

←↑ **Prominent background**

The combination of a darker sky (created by reducing the Blue and Aqua sliders) and darkening the distant mountainside using a quick selection and Levels command brings the background visually nearer to the viewer.

Red		−9
Orange		−17
Yellow		+15
Green		−26
Aqua		−63
Blue		−47
Purple		+14
Magenta		+4
	Auto	

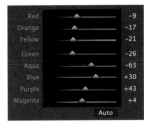

←↑ **Obscured in a haze**

A brighter sky and background has the opposite effect. The lighter tones simulate greater light scattering, and tricks the mind into thinking the distant mountains are farther away.

Red		−9
Orange		−17
Yellow		−21
Green		−26
Aqua		−63
Blue		+30
Purple		+43
Magenta		+4
	Auto	

Going for Contrast

In the early days of photography, film emulsion was orthochromatic (meaning it was only sensitive to blue and green light). This allowed the film to be developed safely under red light conditions. The trouble with orthochromatic film was that the increased sensitivity to blue rendered blue skies very pale. The advent of panchromatic film improved the situation, providing more visually "accurate" blue tones. The introduction of filters further allowed photographers to darken specific tones, and red filters became popular with landscape photographers as they darkened blue skies, creating good contrast with white clouds.

↓ Dorset

Although a perfectly acceptable shot of the rolling landscape in southern England, the image lacks drama, which would be hard to instill in a color version without resorting to oversaturation.

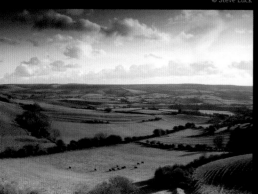

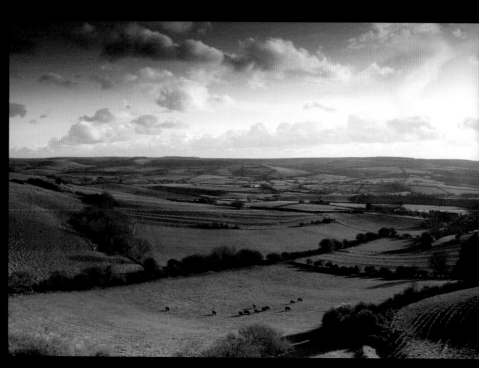

←↑ Step one

The default monochrome version fares little better. In fact, losing the color contrast between the pale blue sky and the green fields results in a generally dull gray image.

Challenge Checklist

→ Use the black-and-white color slider adjustments to maximize tonal contrast.

→ Blue skies can be turned almost black for maximum impact and to contrast strongly with white clouds.

→ Increasing contrast can help an image to appear clearer.

Reds:	18
Yellows:	188
Greens:	194
Cyans:	−200
Blues:	−153
Magentas:	80

←↓ High-contrast skies

Reducing the Cyans and Blues sliders dramatically darkens the blue sky, setting up strong contrast with the clouds. Increasing the Yellows and Greens sliders lightens the fields and helps to emphasize shadows. Reducing the Reds slider darkens the red-brown trees, helping to provide contrast with the lighter fields.

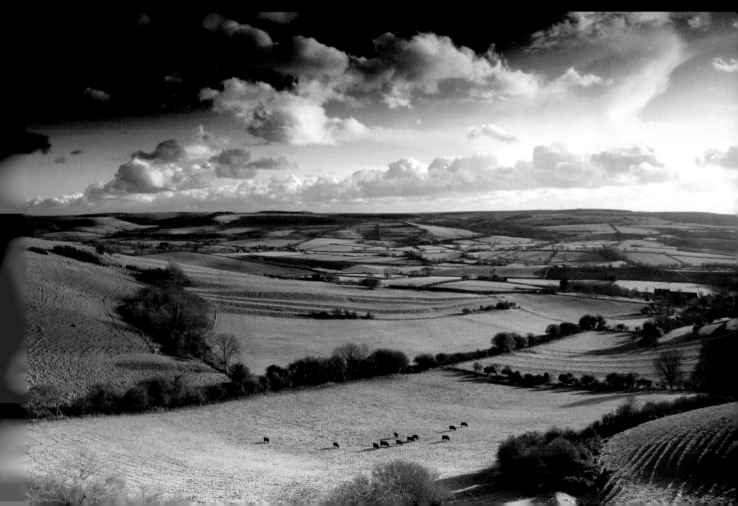

© Dan Goetsch

I saw the black-and-white shot in my mind before I clicked the shutter, as there was a great unintentional pattern in front of me going—from vertical black and white on the left to diagonal black and white on the right. The geometrics and design ended up being more of the subject than the car itself.

Dan Goetsch

Successfully graphic and clear. I like the way in which you've composed the image into several distinct and mainly straight-sided shapes, and then followed this idea through with a conversion in which each block has its own, distinct tone. Taking the central blue stripe of the car down to near-black was a good choice, as was positioning the vehicle's white at a tone midway between the white walls beyond and the sunlit street surface. If it had been me, I might have cropped down more tightly at the top.

Michael Freeman

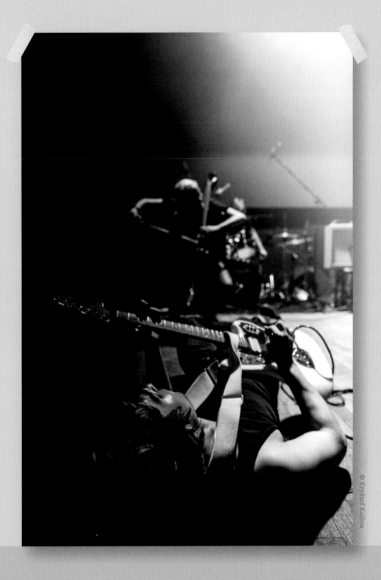

© Kryštof Kalina

Visually, I like how this shot has an almost perfectly vertical line demarcating the transition from black to white; functionally, I like how the performers themselves break up this line into interesting lines and shapes. Going for the contrast might not be done purely for the purpose of creating a visually appealing image, but it might accentuate information or elements within the picture and ease the communication between the image and your audience.

Kryštof Kalina

A personal approach to the lighting, not what most people would do. And it works, precisely because it looks intentional. The almost horizontal lines of the guitar in the foreground and the bow in the background intersect this deep tonal gradient and in a way pin the dark and light halves together. Different, good.

Michael Freeman

A Sense of Depth

↓ Alpine air
With clear, pollution-free air, even distant mountains can appear relatively close. Here for example, the mountain in the background is clearly defined and well-contrasted.

It's a well-known phenomenon that objects are lighter and less contrasting the farther away they are from us. This is because the light is scattered by particles in the atmosphere, and the greater the distance, the greater the number of particles present to scatter the light. We can use this aerial perspective to alter our perception of how near or far specific landmarks are in relation to the camera. And because blue wavelengths are scattered more easily than red, controlling the level of blue tones once an image is converted to black and white affects how distant objects appear.

© Massimo De Candido

Reds:	18
Yellows:	188
Greens:	194
Cyans:	−200
Blues:	−153
Magentas:	80

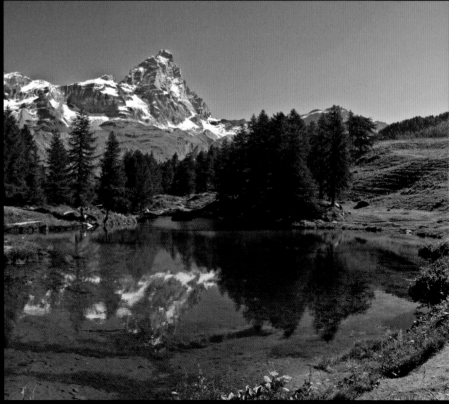

↖↑ Step one
In the default black-and-white version, the mountain appears to be a similar distance away.

Challenge Checklist

→ Use the phenomenon of aerial perspective to artificially add depth to an image by lightening blue elements.

→ Don't increase the Blues and Cyans sliders so much that the blue sky starts to clip.

Reds:	40
Yellows:	109
Greens:	132
Cyans:	74
Blues:	156
Magentas:	80

←↓ Low-contrast horizon
By increasing the Blues and Cyans sliders, the sky and mountain become lighter and and less clearly defined. This has the effect of making the mountain appear farther away. Additional adjustment to the Yellows and Greens sliders lightens the trees in the middle distance, which also helps to enhance the sense of depth.

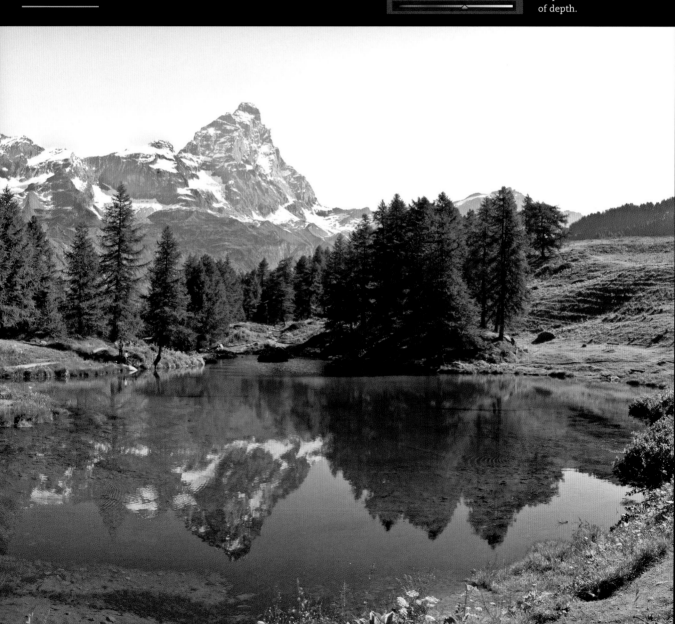

Review

© Benoît Auguste

I am hardly a wildlife photographer, but sometimes photographs present themselves—and it was a miracle that I'd just happened to turn my camera to a portrait orientation the moment the bird took off. The landmark in the background is obvious enough, but I darkened it slightly to contrast with the bright bird in the foreground.
Benoît Auguste

Just the other day I was looking through a selection of images from many different photographers of the Eiffel Tower, searching for something out of the usual run, and not finding many. This is a very good caught moment (evidence that you probably shoot on the streets every day—only practice gets you to this kind of reaction), and while it's a perfect study of a seagull, it's also a light-hearted architectural image. I particularly like the inverted spreading wings versus the spreading arch above.
Michael Freeman

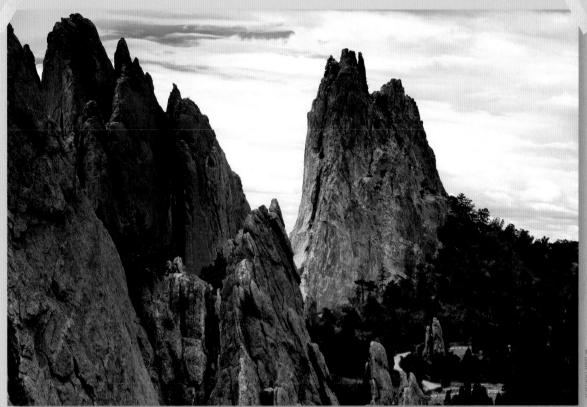

© Dan Goetsch

I liked the way the rocks stood out and wanted to group them together using a telephoto. In the B&W conversion, I brought the reds and yellows up, and the blues way down. From there I wanted more definition to the rocks, so I did a slight dodge on the highlights and burn on the shadows to bring out the contrast.

Dan Goetsch

Pinkish sandstone rocks and green vegetation open the way for a choice of contrasts, and you've chosen a nice balance, with the rocks luminous and the trees dark. Best of all, however, is that you pulled the sky back from being nearly featureless in its color version—it was very milky, but had just a hint of blue and cyan that you were able to exploit. It's successful on depth, remaining understated— you managed to achieve three distinct planes from the nearer rocks, the further pillar, and the sky.

Michael Freeman

Handling Vegetation

In most landscape images, vegetation plays a crucial part in the composition; and when converting a color landscape to black and white it's essential that the conversion treats the vegetation sympathetically, either to ensure that the monochrome version accurately represents the color image, or that the black-and-white controls are used to emphasize the vegetation in one way or another to enhance the black-and-white image.

The main issue with controlling vegetation when converting to monochrome is that, unlike clear skies which are fairly uniform in their color make up—the blue slider will usually control almost the entire sky—vegetation can often be made up of many different hues, ranging from yellow, through green, to oranges and reds.

The multicolored nature of vegetation has two significant impacts when converting to monochrome. First, it may be necessary to try a number of color sliders to see how they impact on the tones of the vegetation—although this is less of an issue with Adobe's Targeted Adjustment tool—and secondly (and more usefully), as there are more tones to experiment with it's easier to differentiate between vegetation of varying hues, so expanding the tonal variation in the monochrome version.

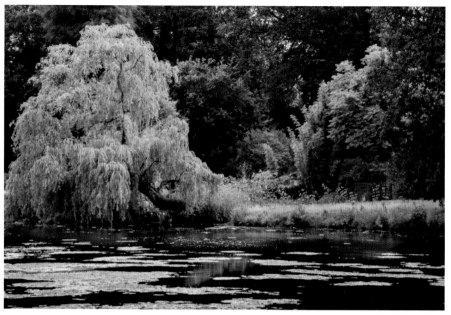

© Steve Luck

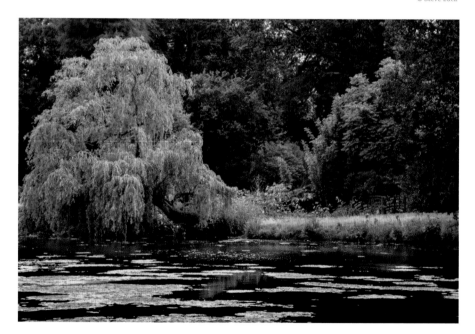

↑↑ Step one
The default black-and-white conversion isn't a bad attempt at differentiating between the different shades of green, although greater contrast could be given to the weeping willow, and the red bridge is totally lost.

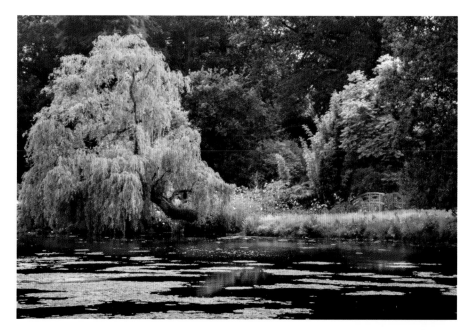

Differentiating the tones

Increasing the Yellow and Green sliders lifts the lighter vegetation of the weeping willow, which now contrasts more strongly with the dark water. Increasing the Cyan and Blue helps to separate out a little more the trees in the background, while Red and Magenta increments brings out the bridge and the wildflowers on the bank.

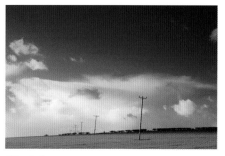 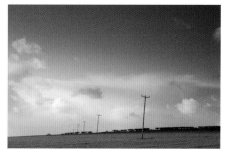

© Steve Luck

Step one

Again, the default black-and-white conversion has created an "accurate" representation of the color original, but without the strong primary green and blue colors the image lacks impact and drama.

Pulling the sky to black

Increasing the luminance of the yellow and green channels, while decreasing the blue components to their maximum negative setting, results in a punchier, more contrasting monochrome version. Increasing the Green and Yellow sliders even more would give an infrared effect.

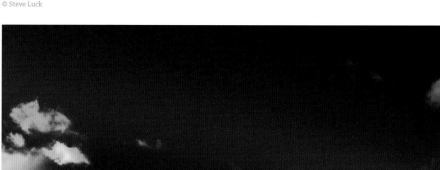

A Green Touch

↓ Appropriate subject
This shot of semiformal gardens belonging to a 12th-century abbey in southwest England exhibits strong form and pattern.

Although vegetation is made up of a variety of colors, including yellows and reds, as well as the more prominent greens, it's possible to target the hues and control the tones of vegetation to create high-contrasting black-and-white landscapes and even near-infrared effects should you wish. Being able to accurately control the tonal range in vegetation allows you to emphasize shape, pattern and form in landscapes that might otherwise be more easily overlooked in a color version of the image.

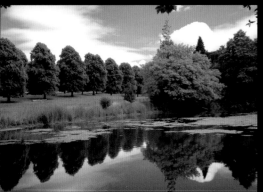

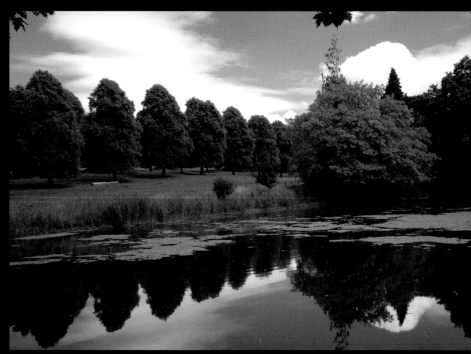

↑ Auto fail
The default black and white version doesn't work at all. The vegetation is too dark, and the pattern we're trying to emphasize is lost.

Challenge Checklist

→ Use the Greens and Yellows sliders to lighten foliage and introduce contrast with other elements in the image.

Reds:	80
Yellows:	101
Greens:	166
Cyans:	−82
Blues:	−116
Magentas:	80

↓ **Bring out the green**
To bring out the detail in the trees and therefore to emphasize the line and pattern (and their reflection in the water) we've lightened considerably the yellow and green components. The trees and grass are now more visible and the line of trees more pronounced. Darkening the sky helps to add impact. Increasing the Yellows slider still further creates an infrared effect.

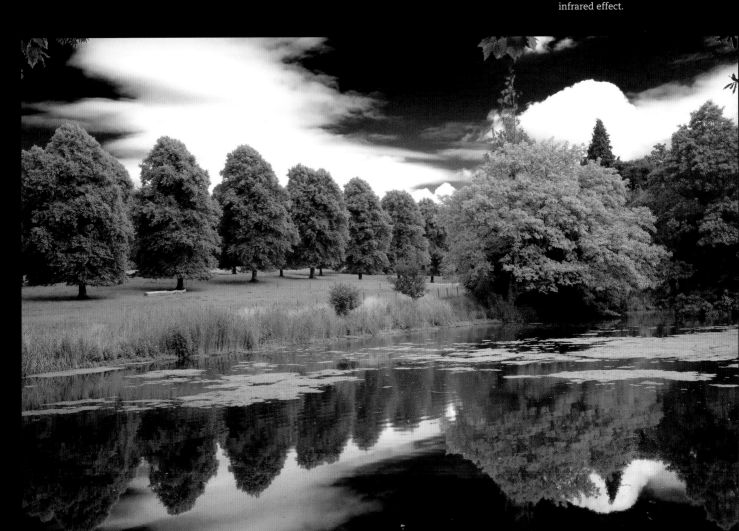

© Josh Ryken

When first converted to black and white, this photo of an Irish hedge maze was dark and lacked contrast. By lightening the yellows and greens I was able to create a high contrast, almost infrared image.

Josh Ryken

Certainly, contrast is one thing that any maze needs, and you've worked that one well. Also, on the larger scale of the maze in relation to the landscape, you've kept it the main subject by lightening it. I don't know how dark it would have appeared in a default conversion, but if it were any darker than the middle distance of fields and hedgerows, the eye would naturally have gone there to the center. I also like the four distinct horizontal bands of landscape elements.

Michael Freeman

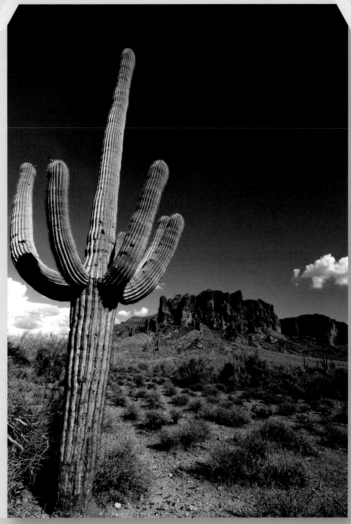

© Dan Goetsch

I took this during early afternoon when the shadows were harsh and the temperature was even worse (112 degrees Fahrenheit, 44.4 C). I went with a black-and-white conversion on this photo to reduce the effect of the hard shadows and to differentiate all of the elements apart from one another.

Dan Goetsch

Those intense Arizona skies are glorious to be under, but irredeemable for photography! One after another, never varying, they make life hard for landscape photographers. In black and white, however, their strong hue becomes a tool to use; and you have, effectively. Backpedalling the blue while increasing green and yellow gives the saguaro the sculptural quality it deserves.

Michael Freeman

Portraits

Like landscapes, portraits have a long association with black-and-white photography. But unlike landscape photography, which has embraced color with a passion, to the point now that it's rare to see a series of black-and-white landscapes, black-and-white portrait photography is still extremely popular; even wedding photographers —traditionally and by necessity quite conservative in their photographic styles—provide their clients with a good selection of black-and-white imagery of the happy day (although their processing is unlikely to stretch to the high-key or low-key themes that were discussed on pages 58–59 and 64–65 respectively).

The reasons that black-and-white portraiture has endured stem from the black-and-white tradition as discussed earlier. Black-and-white portraits have a sense of realism and legitimacy that is sometimes lacking in color counterparts. They cut through the distraction of color and reveal the true essence of the subject with gravitas and authenticity.

Along with the more profound psychological reasons for choosing black and white when creating portraits are some more superficial ones. First, doing away with color can overcome any potential issues of clashing or distracting colors, secondly skin tones can be made to look smoother and healthier, and finally, as has been said many times before, black and white permits greater acceptance of tonal and contrast extremes than color.

© Steve Luck

↑ Skin vs. background
The original color portrait has a good intensity, but the background clashes with the ruddy skin tones. It could be cropped, but the off-center position of the subject is more dynamic.

↓ Step one
With the color distraction removed from a default conversion we are freed up to focus more fully on the portrait itself and its subject.

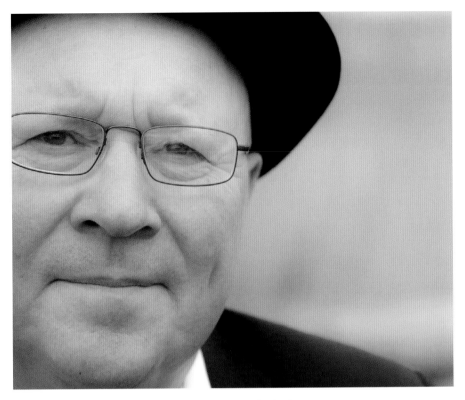

←↑ One interpretation

From the default black and white image, simple curve adjustments can radically alter the mood of the portrait. Brightening the mid-tones creates a light, almost high-key result that has the effect of softening the skin and the facial features. And although the skin looks pale, in the context of the rest of the image, that is the light gray background, it doesn't look unnatural.

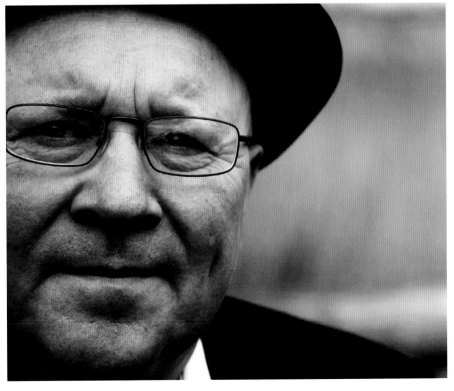

←↑ A grittier take

Here the mood is changed dramatically. A steep S-curve adjustment for strong contrast emphasizes facial lines and shadows, enhances the texture of the skin, and results in a darker, broodier portrait. With this approach you need to take care either to mask the eyes or to lighten them after the Curves adjustment in order to bring back any lost catch lights in the eyes.

Although the skin is much darker than in the previous version, taking the image as a whole, again it looks natural.

The Appearance of Skin

Setting aside deliberate extremes such as high-key, low-key, or any other type of stylized portrait, the aim when converting skin to black and white is to keep it looking as natural as possible. For this reason, we have slightly less artistic or interpretive licence with black and white portraits than we do with most other genres of photography. Our eyes are very attuned to skin tone and color—particularly if the subject is known to us—and anything that doesn't fit in with our accepted range simply looks wrong. This applies to both color and black-and-white portraiture. However, thanks to the versatility of today's black-and-white controls, skin tone can be adjusted quite significantly and still look realistic if you want to separate the subject from the background.

Any discussion of skin color must also of course take into consideration ethnic diversity. Skin tones naturally range from very pale to very dark, but when it comes to black-and-white conversion, skin hue is actually quite similar, being made up of red and yellow hue components. However, the paler the skin the greater the visual impact of red and yellow channel adjustments.

→ Dramatic skin tone changes
In the color original, the subject's face contrasts against the blue background. In a default conversion this contrast is lost. As all skin—to a greater or lesser degree—is made up of red and yellow we can manipulate these channels to create a lighter, softer tone or a darker, more textured tone, both of which reintroduce the contrast as the blue slider moves the other way. Increase red and yellow for a lighter, delicate look and decrease the same channels for a darker, more masculine tone.

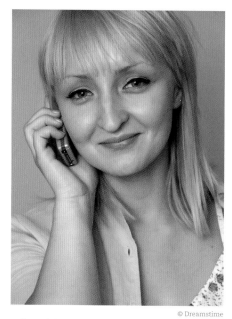

Color original

© Dreamstime

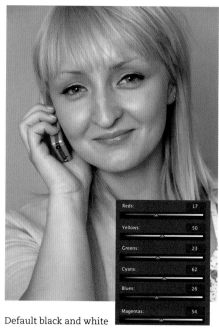

Default black and white

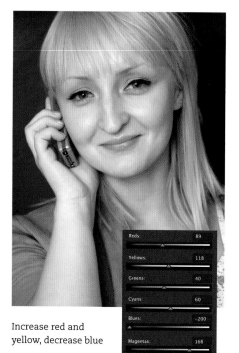

Increase red and yellow, decrease blue

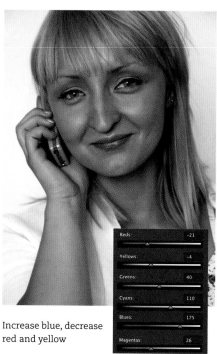

Increase blue, decrease red and yellow

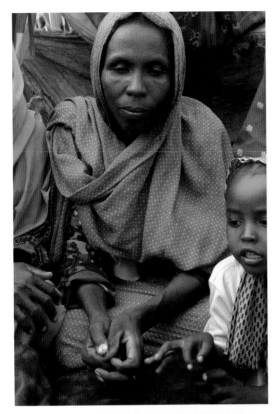

Reds:	21
Yellows:	55
Greens:	23
Cyans:	56
Blues:	22
Magentas:	54

← Sudanese skin

A similar scenario exists in this shot. From a tonal perspective, the contrast is missing in the default black and white conversion. Again, using the same settings as in the previous series, contrast can be brought back by manipulation the red, yellow and blue color channels. However, comparing the woman's face in the two manipulated versions with the default settings, there appears less tonal movement away from the default when compared with the lighter Caucasian skin.

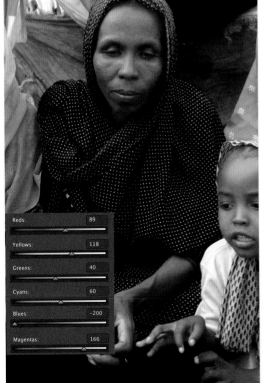

Reds:	89
Yellows:	118
Greens:	40
Cyans:	60
Blues:	-200
Magentas:	166

Reds:	-21
Yellows:	-4
Greens:	40
Cyans:	110
Blues:	175
Magentas:	26

Improving Skin Tone

The subtle pink-red tones of Caucasian skin make it particularly susceptible to discoloration caused by rashes, dry skin, sunburn, or a host of other dermatological conditions. Such discoloration is more pronounced in the delicate skin of young children. An effective way to improve skin tone is to dispense with color altogether and use hue sliders to target the darker red patches of the affected areas so that either they are made lighter, or the paler, unaffected skin is made darker—either way the intention is to even out the tones across the face to create smoother healthier-looking skin.

↓ Cute, but splotchy skin
When subjected to even short periods of extreme cold, young pale skin can quickly appear patchy red in places.

© Kjara Ginger

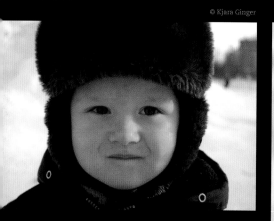

Reds:	40
Yellows:	60
Greens:	40
Cyans:	60
Blues:	20
Magentas:	80

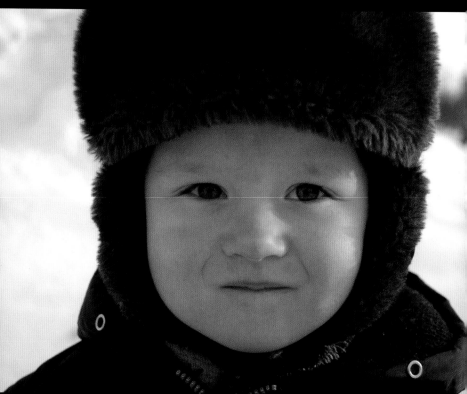

↑ Worse, at first
The areas of darker red are quite pronounced in this shot, and even show up darker in the default black and white conversion.

Challenge Checklist

→ The color and tones of Caucasian skin in particular can be altered dramatically with hue sliders.

→ Assess adjustments carefully, as even in grayscale images, skin tones can quickly look unreal if care is not taken.

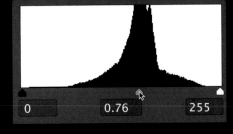

Reds: 88
Yellows: 60
Greens: 56
Cyans: 135
Blues: 20
Magentas: 80

0 0.76 255

▼ B&W for skin smoothing

Brightening the red tones has the desired effect of smoothing the overall skin tones so that the dark patches of skin are no longer so visible. However, such an adjustment can make the skin appear too light and translucent. To combat this make a quick selection of the face and darken the mid-tones slightly.

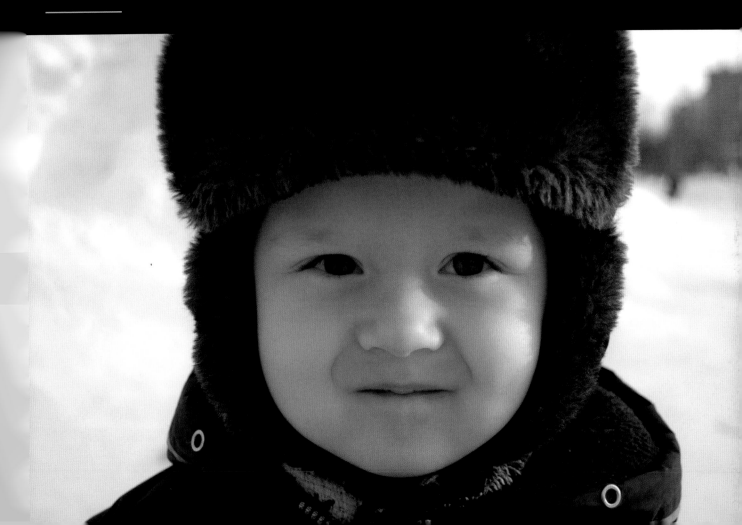

Review

© Dan Goetsch

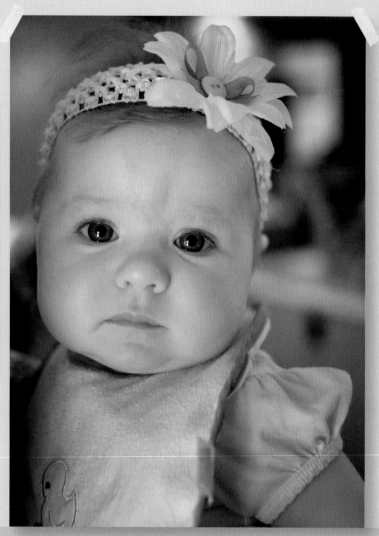

She is my niece and one of the many infants that get the "stork bite" mark when they are born. This leaves a small reddish streak on their skin around the forehead which eventually clears up. I went with B&W to reduce the focus on the red mark and bring out the soft tones of the skin. In photoshop I added a black and white adjustment layer and brought up the reds to lighten the skin tones as well as the yellows.

Dan Goetsch

By targeting the stronger reds (the mark, the upper cheeks, and the chin), you achieved an overall tonal smoothing in the face, which leaves our attention fully taken by those eyes and that expression. B&W was definitely the way to go, not least because the surroundings are no longer distractions.

Michael Freeman

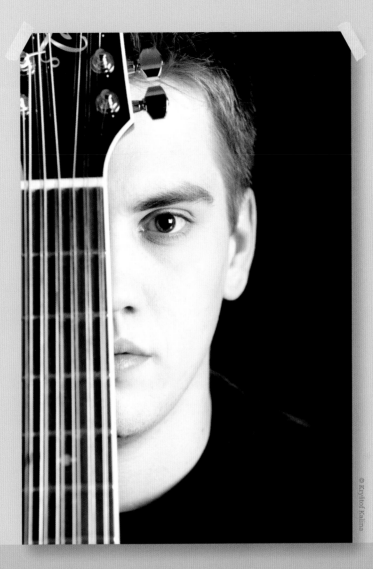

© Kryštof Kalina

Almost glowing in the dark. Such an approach lets you hide skin defects while keeping manliness within the portrayed person. It is a nice alternative to glamor-like skin softening, which could bring a feminine feel where you wouldn't want it.

Kryštof Kalina

That's a good point about the difference between male and female skin. Techniques like reducing Clarity for softening skin texture are widely used for female portraits, but tweaking the reds and yellows and bringing the overall level up here do a more appropriate job. Caucasian skin usually has a subtle mixture of yellow and red, and working at a fine level with these sliders is the key to evening out the facial tones. I also, incidentally, like the graphic division of the face down the center line.

Michael Freeman

Architecture & the Street

Architecture of all kinds—from the towering Gothic cathedrals of medieval Europe to the ultra modern examples of North America and Asia—is an ideal subject for black and white photography. Although architects may ponder the colors of the materials they're using, apart from a few notable exceptions, color is rarely a primary architectural consideration. Instead buildings are designed to show off form and line, balance and movement, light and space (many of the photographer's key compositional tools). Black and white, therefore, immediately eradicates any potentially distracting color residue, and cuts straight to the fundamental nature of the building.

© Steve Luck

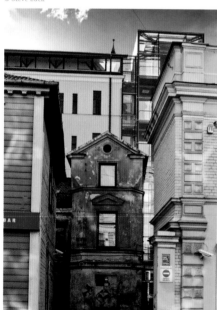

↑→ Differentiate the architecture

The aim of this shot was to show the late 19th-century building in the center being crowded out by ever bigger and more modern constructions. Despite the difference in age, the buildings are fairly uniform in color, making it hard to differentiate them using the black-and-white channel adjustment sliders. Instead, the surrounding buildings were selected and brightened using a Levels command.

↑ Bring out the detail with microcontrast

Black-and-white architectural photography can celebrate the majestic form of buildings, such as this cathedral front in Prague, without color to distract the viewer.

↑ The golden hour in monochrome

The streets are full of strong lines, gritty textures and messages. If you want to add drama to street photography, shoot when the sun's low in the sky—at this time there will be raking shadows that help model textures, and contrasting areas of light and shade that can be almost theatrical in appearance.

The lack of bright colors in much architecture does mean that it can be difficult to separate tonally one building from another when converting to black and white. Whereas in most photographic genres you can play around with hue adjustments to tease out tonal separation, when processing architecture for monochrome, you'll be relying more on Curves and Levels commands to enhance contrast.

Street photography, made famous by photographers such as Henri Cartier-Bresson and Robert Frank, is a form of social documentary, and another genre of photography that excels in black and white. Like portraiture, street photography also benefits from the "realism" of black and white as inherited from the famous documentary photography of the early to middle 20th century. And as well as providing images of candid moments in a single frame that are often all the more immediate and intense for being presented in black and white, street photographers also look out for strong geometrical shapes, textures, shadows and light to emphasize the statements they are making about the human condition. Such compositional tools, as we know, are usually enhanced by a monochrome treatment.

→ Diversion

Intended as a visual pun on the sign and the "diverting" attractions on offer, the black-and-white version provides clarity of the lettering against a black rather than multicolored background.

Buildings or Street Life

Large cityscapes often provide an ideal opportunity to explore the bold shapes and patterns found in modern (and not so modern) buildings. When looking to emphasize shapes it's often a case of trial and error with the hue sliders to bring out maximum contrast between the buildings' outlines and any backgrounds.

↘ A classic shot

London has some iconic buildings, both old and new; and although this color image shows the juxtaposition nicely, greater emphasis of the architectural styles would make a more powerful statement.

↓ Not distinct enough

In color, the buildings are tonally similar and this makes it difficult to highlight the differences in shape and form. This problem is carried through to the default black and white version.

© TJImages

Challenge Checklist

→ Seek out the forms, patterns, and shapes created by a city's architecture.

→ Look for abstract compositions in the details and structures of buildings.

Reds:	265
Yellows:	-65
Greens:	40
Cyans:	-100
Blues:	-168
Magentas:	80

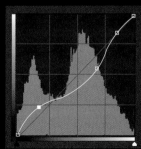

↑ Curves to bring out detail and contrast

By experimenting with the various hue sliders it's possible optimize the tones to emphasize the outlines of the buildings. However, the hue sliders can only do so much. With this image increasing contrast while also targeting certain mid-tones helps to flatten the image so that there's less depth to the image, making a more direct comparison with the different buildings.

Review

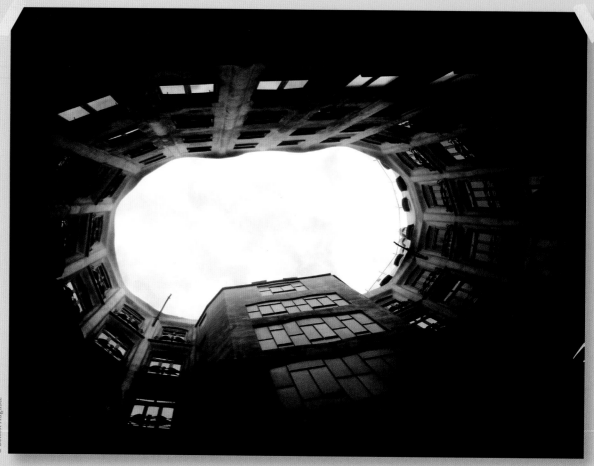

© Benoît Auguste

Too often I find that buildings are only ever viewed head-on from ground level, which is only one of so many possible perspectives (this is why I like high angles and bird's eye-views so much). So when I looked up and saw this curved structure encircling me below and the sky above, I knew it would be a good shot. In post-production I often like adding a vignette, but this one already had a strong natural vignette from the sky diffusing down into the interior space.

Benoît Auguste

This shot makes me think that you could photograph an entire city in terms of its vertigo. Cityscapes are full of verticality, but as you say it's the axis that is most often ignored. You held the tones well—nothing lost in the sky while there are enough deep reflections in the interior façades to show all we need to know.

Michael Freeman

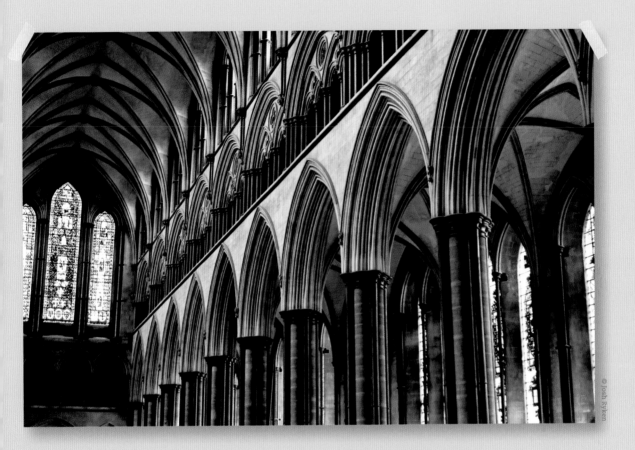

© Josh Ryken

I felt that a black-and-white image showcased the repeating pattern of pillars and arches. I used medium contrast; enough that the shape is evident, but not so much that the details are lost.

Josh Ryken

My first impression is of good tonal balance, with a rich feeling in the well separated mid-tones. In particular, you've held the stained glass windows in sufficient detail without resorting to a tone-mapped look. My only criticism, and it's a personal one, is that with such rigorous formality in the architecture, I would have liked to see the verticals all stay vertical. Even without a shift lens, that would be possible by applying some perspective correction in post-production.

Michael Freeman

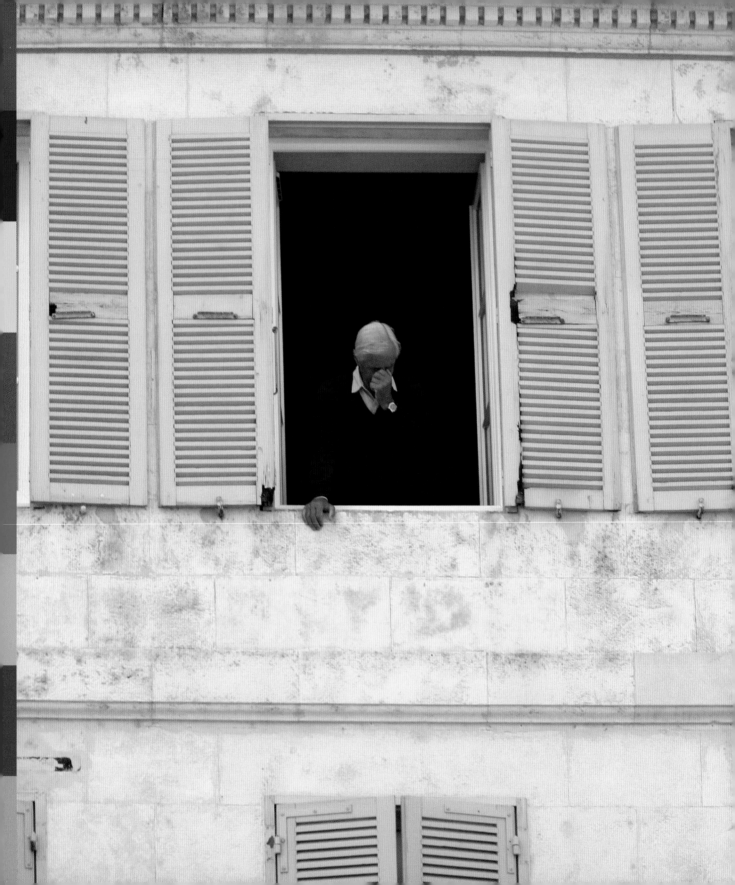

Advanced Techniques

Finally, to complete our exploration of the tools, techniques, and artistic approaches behind monochrome conversion, in this last section we'll concentrate on some unique examples that require more advanced techniques. For example, despite the versatility of today's black-and-white conversion commands, there may be cases where applying the same conversion globally simply doesn't work—in which case you'll need to apply conversions selectively. We'll show you how.

Other topics covered involve reintroducing some color back to your monochrome image. There are a number of reasons for subtle color toning, whether to replicate a film process or to give an image greater resonance, and here we cover some of the best approaches. Equally striking is retaining the color in one or two elements of a photograph. Again, this can be achieved in a number of ways, all of which are explained here.

Selective Combinations

Although post-production software and Raw editors now have powerful and versatile black-and-white conversion tools (together with standard brightness and contrast controls) that allow you to fine-tune monochrome images with a variety of hue and brightness adjustments, there will be times when even these commands don't quite provide the level of adjustment you need. There can be a number of reasons for this—extreme contrast, or if the saturation of the hue is insufficient to bring about any great change in brightness when adjusting the corresponding slider, or when the colors of the area you want to brighten are the same as areas that you want to leave unaffected are three common examples.

In cases where manipulating sliders doesn't do the trick, you'll have to resort to alternative methods. One option for cases of extreme contrast is to try a Shadows/Highlights command and this can often produce the desired result. However, for a more selective approach, you may find that creating duplicate layers of varying brightness levels and carefully erasing the unwanted area gives you greater control. A similar method is to use a layer mask. This gives you even more control.

© Steve Luck

↑ **Half & half**
In this shot of an old street in the city of Bath, southwest England, the bright conditions have resulted in one side of the street being well lit, while the other side is in dark shadow.

← Adjust the mid-tones
The first step is to add a Levels adjustment layer between the original color background layer and the Black & White adjustment layer. Set the gray point until detail is clearly visible in the shadow regions. Naturally, the rest of the image will also become lighter.

↑→ Balance it out with a layer mask
Finally, add a layer mask to the Levels adjustment layer. Painting black on the mask will reveal the darker image underneath, while leaving it white ensures that the Levels adjustment layer is applied to the relevant part of the image. When satisfied with the correction, flatten the image and save.

Differential Treatment

↓ Welsh beach scene
This beautifully unspoiled stretch of sandy beach, with dark blue skies, puffy white clouds, and green grass, has the potential for a powerful, high-contrast black-and-white image.

We've seen how using layers, adjustment layers, and layer masks can help to lift shadows and leave the rest of the image untouched. Here, we can use a similar technique in those cases where elements in a scene share similar colors. Naturally, in such cases, lightening or darkening an element using hue control is going to lighten or darken any other elements in which the same or similar colors appear.

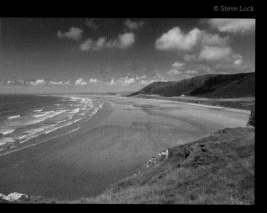

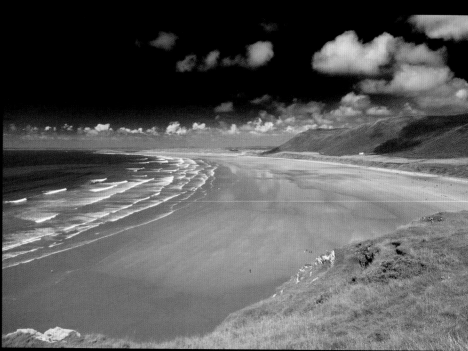

←↑ Step one
Following the standard procedure when creating a high-contrasting landscape image and reducing the Blues and Cyans sliders has created the dark skies, which are now contrasting strongly with the white clouds, but the ocean, which reflects much of the blue from the sky, has also turned very black. To me, although the surf is now nicely revealed, the ocean's too black.

Challenge Checklist

→ Seek out a scene or setting wherein the color version has clearly distinct tones that lose their distinction when converted to black and white, then tackle this problem using local-area adjustments or layers.

↙↓ Joining sea and land
There are many ways we could lighten the ocean to the default monochrome conversion. One of the best ways in terms of control is to use a layer mask. The background image was duplicated and a default black-and-white conversion applied to it. By painting black over the ocean on the default monochrome version the dark sea is masked from the dark blue adjustment and the ocean becomes lighter.

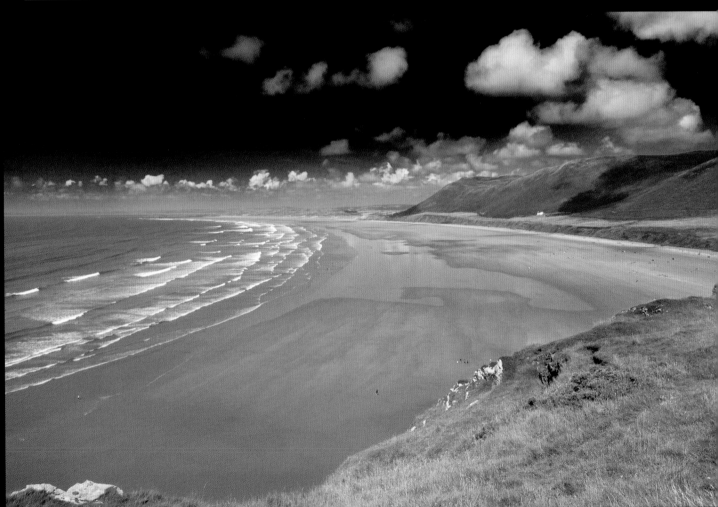

Review

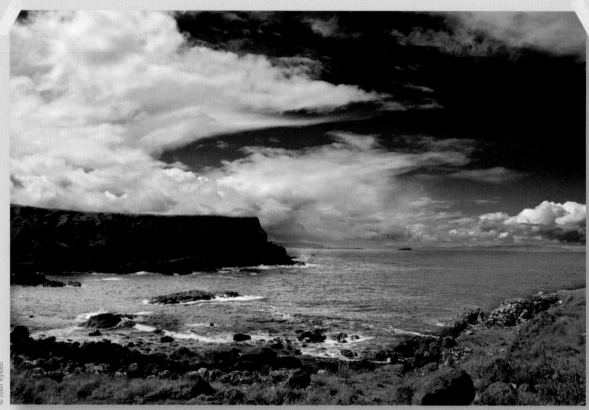

© Josh Ryken

A large majority of this image is sky and water, which are both blue and lack contrast without editing. I used a layer mask to selectively lighten the water and create contrast with the sky.

Josh Ryken

Sea and sky separate more naturally in color than in black and white, and it's rarely a problem, but as you've experienced here, there's often a zone where, in black and white, one flows into the other. You already strengthened the contrast between sky and clouds by adjusting the blue downwards, but selectively lightening the water (counter to how it typically appears) was a good move, and breathes life into the picture.

Michael Freeman

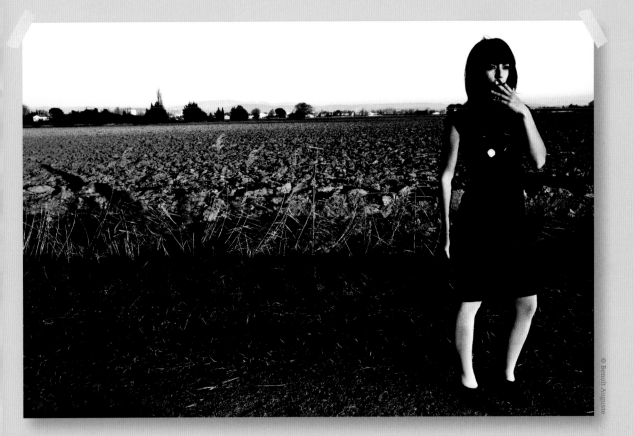

This shot was meant to be all about contrast—between a country setting and a beautiful woman dressed for a night on the town. However, the color of her stockings matched too closely the color of the earthen field behind, so a local brightening adjustment was needed to make them really pop out and establish the foreground.

Benoît Auguste

Upping the contrast has another effect in this picture, which is adding to its surreal impression. First it draws attention to the long shadow cast by the girl cast, and then to the lightening of the close foreground at the bottom edge of the frame, so that we sense something like a car headlight from the right. But then we see a sky that could be daylight, and are left with more questions added to the situation itself—this night on the town already has a strange beginning!

Michael Freeman

Split Toning

The idea of toning a black-and-white image originated in the darkroom, and involves replacing the silver element in the print with other more stable silver compounds. As well as giving prints a desirable red or blue color, toning also gives prints a longer lease on life. Probably the best-known toning process is sepia toning which provides a warmer tone to black-and-white prints.

As its name suggests, in analog printing split toning involves the use of two toners, one to tone the highlights and one the shadows. Both toning and split toning are easy to replicate in the digital darkroom, particularly with those Raw editors that have a dedicated Split Toning command, such as Lightroom. However, even if your editing software doesn't feature such a dedicated control, it's easy enough to recreate a split tone effect using just a couple of Curve adjustments.

↘→ Dedicated controls

Along with the presets, Lightroom also features a Split Toning panel in which you can select the hue and saturation strength of both the highlights and the shadows, and then determine at what point these blend together.

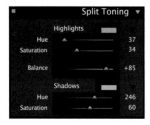

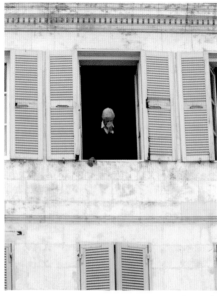

←↑ Make use of presets

Raw-conversion software, such as Aperture and Lightroom, features a number of black and white tone presets. These come installed with the program, but more presets can be downloaded from the internet.

© Steve Luck

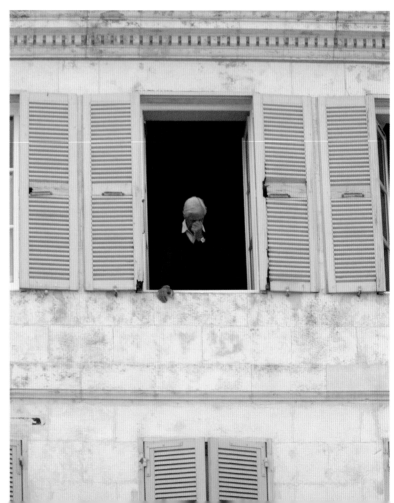

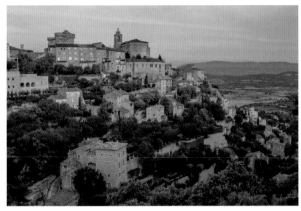

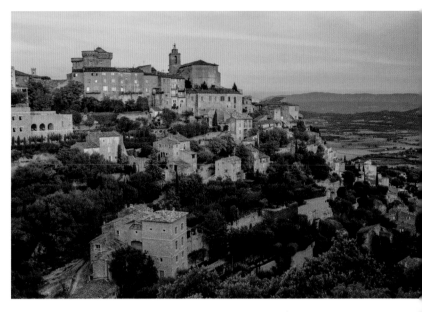

© Steve Luck

←↑ Working with layers

In post-production software (as opposed to Raw-conversion programs), create a Curves adjustment layer. Select one of either Red, Green, or Blue in the channel pull-down menu and create a gentle S-curve. This will add the selected tone to the highlights and introduce the opposite tone to the shadows.

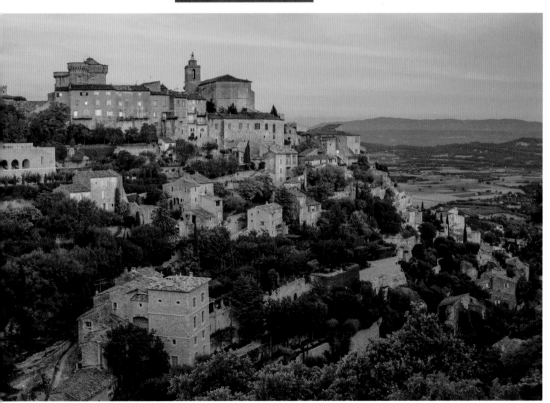

←↑ Shadows vs. highlights

If you want to add further tones, select another color from the channel pull-down menu, and this time create a reverse S-curve. In this example, blue is added to the shadows, and yellow to the highlights.

Subtle Colorings

↓ A lush & colorful start
This spectacular coastal view has a soft, gentle atmosphere that lends itself well to a tinted monochrome treatment.

We've seen how adding some subtle coloring to a straight grayscale image can alter the mood and add variety to a collection of monochrome shots. There are numerous ways to add color to a black-and-white image. Using the color channels in a Curves command offers a high degree of control, but there are more simple routes that can provide results that are just as satisfactory.

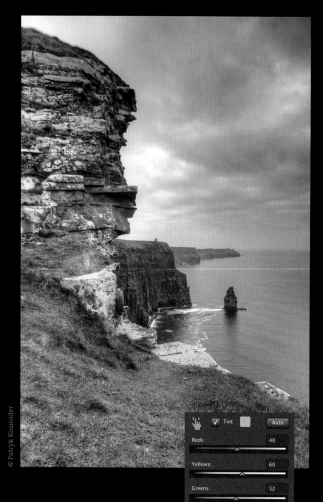

© Patryk Kosmider

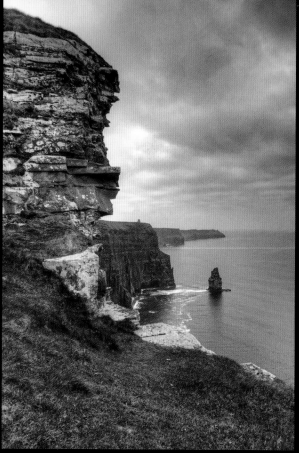

←↑ Tint with a click
One of the quickest ways to produce a tinted monochrome is by using a Black & White adjustment layer. Simply click the Tint box and select a color by clicking in the color box.

Challenge Checklist

→ Subtle is the key word—don't go overboard, just choose a tone that fits the subject matter in some way. You should still see the subject first, and tone second.

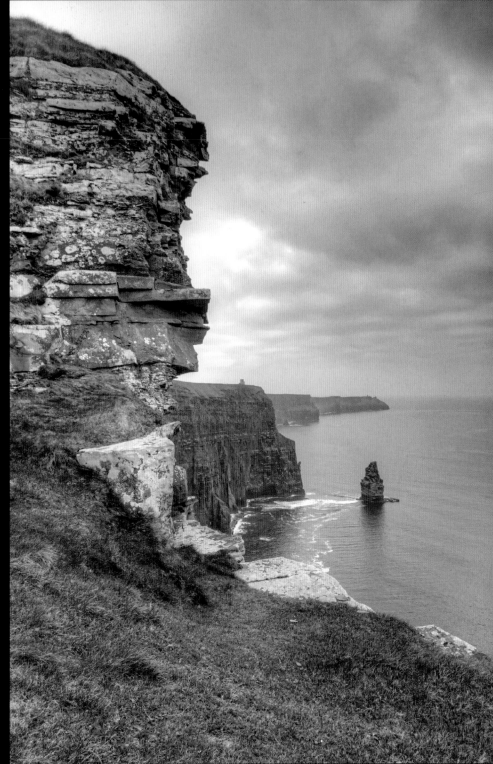

↑→ Delicate coloring

A little more work than the previous option is to create a new layer and fill it with a color of your choice using the Color Picker. Set the color layer blending mode to Color and set the opacity to a strength that looks appropriate for the image. Experiment with other blending mode options.

Review

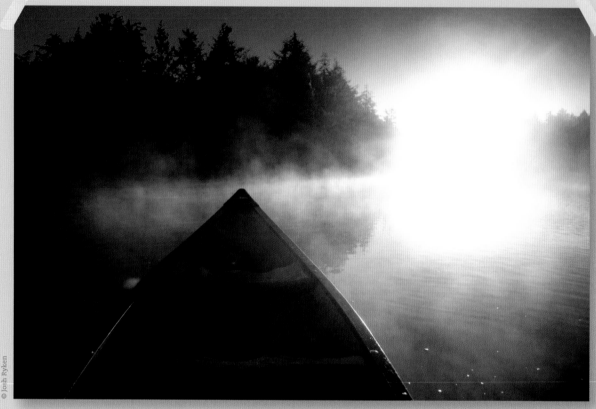

© Josh Ryken

I gave this photo of a foggy morning a yellow tint, which changed the mood from dark and depressing black and white to a happy golden morning.
Josh Ryken

This is in any case a very clean and graphic image, with a wonderful atmosphere drifting through the shapes. Ordinarily I'm a little suspicious of coloring black-and-white images, but in this case it seems entirely appropriate. As you say, it lifts the scene into a happy, golden state.
Michael Freeman

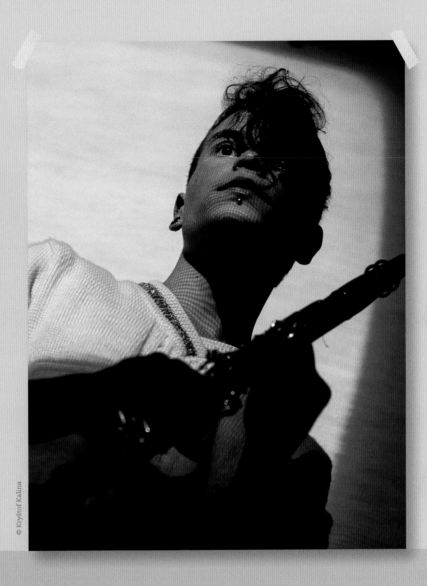

© Kryštof Kalina

This picture from a music gig was already lit mostly by one color, which has been slightly shifted to complement the large screen in the background. All other colors were then suppressed to preserve a uniformly blue tone.

Kryštof Kalina

Single-color lighting has long been a feature of live music, so at first glance this reads as a color image; but after a second you notice the normally visible small fluctuations in hue are absent, and then realize more thought and work has gone into this image. And the slight leaning towards violet in this rich blue is very striking.

Michael Freeman

Spot Color

All of the color images printed in this book (apologies to e-book readers) are made up of four separate colors applied by four separate rollers—cyan, magenta, yellow, and black. Together, just these four colors can produce millions of different colors. Spot color is different. Spot color is a printing term used to describe a single color printed on a page by a single roller.

Picking out a single bright color to remain untouched when performing a black-and-white conversion can produce some striking effects and emphasize certain elements of an image. Traditionally, this was achieved by hand painting the object(s) in question, but there are a number of ways of achieving similar effects using image-editing software. We won't go into the process of emulating a hand-colored print using a number of colors as this is not the intention here. Instead we shall look at two ways of isolating specific subjects so that they retain their color as the remainder of the image is converted to black and white.

© Steve Luck

↗↗→ **Desaturate method**
A quick and easy way to isolate a specific color in an image is to desaturate all the other colors. This works fine if nothing else in the image is made up of the color you wish to retain. However, life is rarely that simple. Here we can still see residual blue tones left in the background.

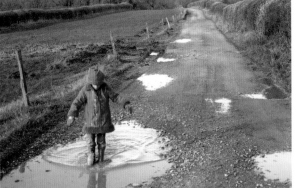

© Steve Luck

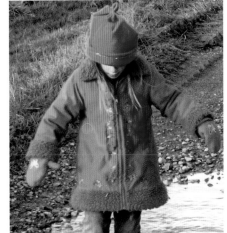

←←↑ Manual method

A longer but more powerful way to isolate colors is to add a layer mask to the black and white adjustment layer. Now you can simply paint over the mask in black wherever you want the color to show through.

←←↓ Spot with tint

Now with the colored figure isolated from the rest of the image, you can apply all sorts of other effects without affecting the figure.

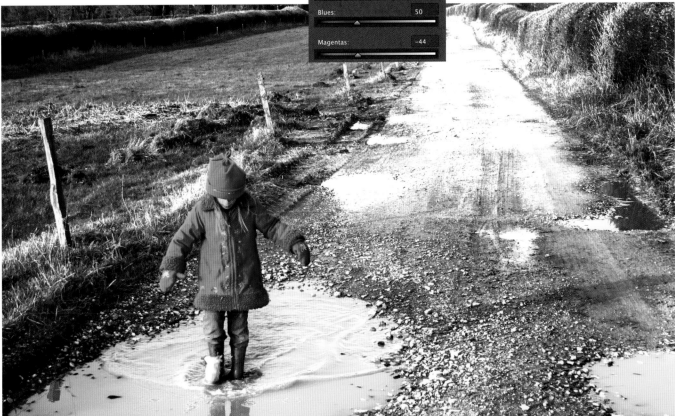

Color in Black & White

Isolating and retaining a single color in a color image is a trick that has been used for many years, perhaps most notably in a number of advertising campaigns. As always there are many ways of achieving the result, and how you go about it will depend on the source image and the color you want to retain.

© Freesurf

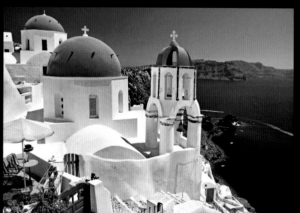

← Santorini
In this iconic image of a church on the Greek island, I want to keep the domes bright blue, as these are a particularly well-known landmark.

↗ Desaturate all but blue
With this particular example, as the elements we want to keep are saturated blue, a logical step was to simply set the saturation for all the other colors to –100 in a Hue/Saturation adjustment layer.

↑→ Work in layers
The next step was to add a Black and White adjustment layer and a duplicate background layer. Then, by arranging the layers in the order shown, it was simply a case of using the Eraser tool to quickly paint out the blue from the sea, sky, and woodwork.

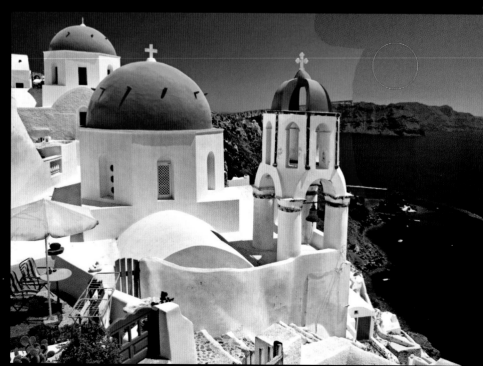

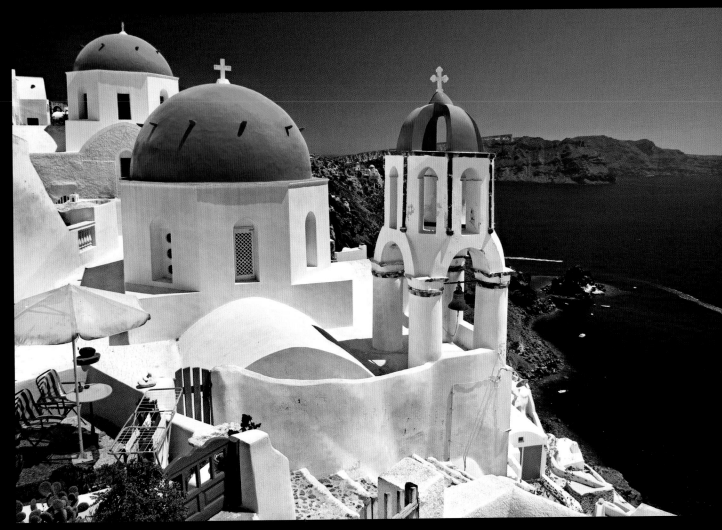

↑ Black & white & blue
The final image shows a black-and-white scene with only the domes colored.

Challenge Checklist

→ Keep this challenge from veering into the realm of a gimmick— try to isolate a color that still contributes thematically to your subject, or is meaningful in its own way.

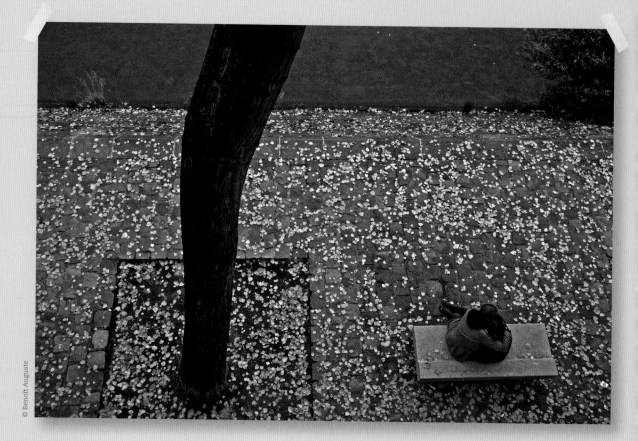

© Benoît Auguste

I'm usually an orthodox B&W shooter, so this particular shot is unusual for me. I realized that preserving just the color of the fallen leaves created a completely new image, different from both the B&W and color versions. It's the dominant elements of the tree and couple on the bench remaining in B&W that make it work, I think.

Benoît Auguste

A successful and quite delicate use of this often-abused technique. You're quite right that the looming tree trunk and the couple on the bench are the combined elements that lock it down, and one of the results is that it reads as a fundamentally black and white image, onto which the colored autumn leaves have landed. That gives it a second layer of meaning—a sprinkling of leaves on the scene, and of color on the print.

Michael Freeman

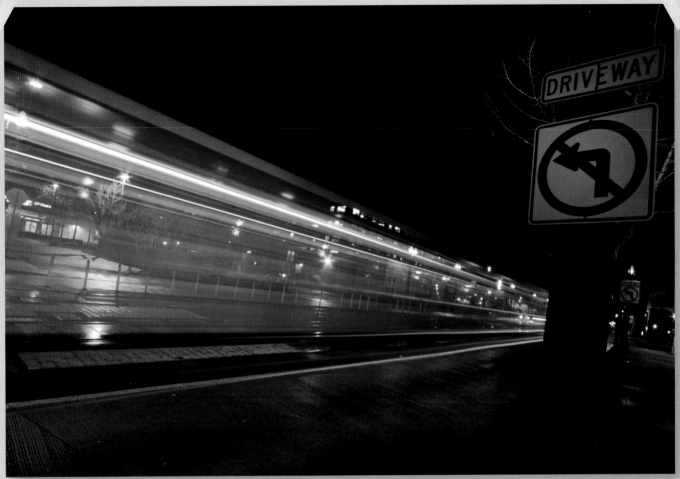

© Dan Goetsch

I set up my tripod just in time as the cabin of the train came by. During the exposure, I also noticed the Driveway sign and took out my flashlight to paint on some light. In post, I wanted to make the light streak really pop. I decided to play with a selective coloring edit as an option and I really liked how it turned out.

Dan Goetsch

Part-color always sets up a new relationship in an image, between the color and the mono elements. I find it interesting to see how your approach to this duality is quite different from Benoît's opposite. It works, but does so in another way. Because of the strong angular component to the composition, tilted and converging, the colored light-streaking drives like a wedge into the image from the left. There's very much a feeling of the color penetrating the black-and-white night scene.

Michael Freeman

Glossary

action Photoshop keystrokes recorded to automate routine activity.

additive primary colors The three colors red, blue, and green, which can be combined to create any other color. When superimposed on each other they produce white.

adjustment layer A layer in a Photoshop image that adjust the appearance of layers beneath it, and keep editing adjustment distinct from the original image data.

aliasing Jagged edges in a digital image, caused by the square of its constituent pixels.

alpha channel A grayscale version of the image that can be used with the color channels for saving a mask or selection.

anti-aliasing Smoothing jagged edges by introducing additional pixels of intermediate tone.

aperture The opening behind the camera lens through which light passes on its way to the image sensor (CCD/CMOS).

application (program) Software designed to make the computer perform a specific task. So, image-editing is an application, as is word-processing. System software, however, is not an application, as it controls the running of the computer.

artifact Foreign shapes degrading a digital image as a result of its capture, manipulation, or output.

backlighting The result of shooting with a light source, natural or artificial, behind the subject to create a silhouette or rim-lighting effect.

backup A copy of either a file or a program, for safety reasons, in case the original becomes damaged or lost. The correct procedure for making backups is on a regular basis, while spending less time making each one than it would take to redo the work lost.

ballast The power pack unit for an HMI light which provides a high initial voltage.

banding Unwanted effect in a tone or color gradient in which bands appear instead of a smooth transition. It can be corrected by higher resolution and more steps, and by adding noise to confuse that part of the image.

bit (binary digit) The smallest data unit of binary computing, being a single 1 or 0.

bit depth The number of bits of color data for each pixel in a digital image. A photographic-quality image needs eight bits for each of the red, green, and blue channels, making for a bit depth of 24.

bitmap (bitmapped image) Image composed of a pattern of pixels, as opposed to a mathematically defined object (an object-oriented image). The more pixels used for one image, the higher its resolution. This is the normal form of a scanned photograph.

blending mode The calculation that controls how one Photoshop layer is composited with other layers.

blown out Containing no detail, usually referring to overexposed parts of an image.

boom A support arm for attaching lights or fittings to.

bracketing A method of ensuring a correctly exposed photograph by taking three shots; one with the supposed correct exposure, one slightly underexposed, and one slightly overexposed.

brightness The level of light intensity. One of the three dimensions of color in the HSB color system. *See also* Hue and Saturation

buffer An area of temporary data storage, normally used to absorb differences in the speed of operation between devices. For instance, a file can usually be sent to an output device, such as a printer, faster than that device can work. A buffer stores the data so that the main program can continue operating.

burn A photographic darkroom and Photoshop technique to darken selective parts of an image.

burned out Containing no detail, usually referring to overexposed parts of an image.

byte Eight bits. The basic unit of desktop computing. 1,024 bytes equals one kilobyte (KB), 1,024 kilobytes equals one megabyte.

calibration The process of adjusting a device, such as a monitor, so that it works consistently with others, such as scanners and film recorders.

catalog A program that records the contents of folders, displays image files' thumbnails and large previews, and allow metadata entry. While folders may be shown, their contents are not updated in real time, but rather only when instructed, and searches are performed upon the database.

Camera Raw In Photoshop, the module resonsible for converting Raw images from any digital camera.

CCD (Charge-Coupled Device) A tiny photocell used to convert light into an electronic signal. Used in densely packed arrays, CCDs are the recording medium in most digital cameras.

channel Part of an image as stored in the computer; similar to a layer. Commonly, a color image will have a channel allocated to each primary color (e.g. RGB) and sometimes one or more for a mask or other visual effects.

clipping An absence of detail in image areas because the brightness values record either complete black or pure white.

CMOS (Complementary Metal-Oxide Semiconductor) An alternative sensor technology to the CCD, CMOS chips are used in ultra-high-resolution cameras from Canon and Kodak.

CMYK (Cyan, Magenta, Yellow, Key) The four process colors used for printing, including black (key).

color gamut The range of color that can be produced by an output device, such as a printer, a monitor, or a film recorder.

color temperature A way of describing the color differences in light, measured in Kelvins and using a scale that ranges from dull red (1900 K), through orange, to yellow, white, and blue (10,000 K).

compression Reduction of image size by use of algorithms to discard superfluous data.

contrast The range of tones across an image, from bright highlights to dark shadows.

cropping The process of removing unwanted areas of an image, leaving behind the most significant elements.

curves In image editing, a method of mapping pixels' brightness values to the value at which they are output.

depth of field The distance in front of and behind the point of focus in a photograph, in which the scene remains in acceptable sharp focus.

derivative An image file produced from an original, for instance the JPEG or PSD file saved after a Raw original has been converted.

destructive Permanent change of pixels' brightness values, tones, or positions.

dialog box An onscreen window, part of a program, for entering settings to complete a procedure.

diffusion The scattering of light by a material, resulting in a softening of the light and of any shadows cast. Diffusion occurs in nature through mist and cloud cover, and can also be simulated using diffusion sheets and soft-boxes.

digital A way of representing data as a number of distinct units. A digital image needs a very large number of units so that it appears as a continuous-tone image to the eye; when it is displayed these are in the form of pixels.

digital asset management The practice of downloading, backing up, evaluating, describing, categorizing, selecting, and archiving digital image files.

DMax (Maximum Density) The maximum density—that is, the darkest tone—that can be recorded by a device.

DMin (Minimum Density) The minimum density—that is, the brightest tone—that can be recorded by a device.

dodge A photographic darkroom and Photoshop technique to brighten selective parts of an image.

DPI Dots per inch, the standard measure of print resolution.

dynamic range The range of tones that an imaging device can distinguish, measured as the difference between its dmin and dmax. It is affected by the sensitivity of the hardware and by the bit depth.

EXIF Commonly refers to exposure information stored with digital image files; strictly refers to the file format of this information itself.

ƒ-stop The ratio of the focal length to the aperture diameter, expressed as $f/2.8$, $f/4$, $f/5.6$, etc.

file format The method of writing and storing a digital image. Formats commonly used for photographs include tiff, pict, bmp, and jpeg (the latter is also a means of compression).

filter (1) A thin sheet of transparent material placed over a camera lens or light source to modify the quality or color of the light passing through. **(2)** A feature in an image-editing application that alters or transforms selected pixels for some kind of visual effect.

focal length The distance between the optical center of a lens and its point of focus when the lens is focused on infinity.

focal point The point at which light rays passing through a lens converge.

focal range The range over which a camera or lens is able to focus on a subject (for example, 0.5m to Infinity).

focus The optical state where the light rays converge on the film or CCD to produce the sharpest possible image.

fringe In image-editing, an unwanted border effect to a selection, where the pixels combine some of the colors inside the selection and some from the background.

frontal light Light that hits the subject from behind the camera, creating bright, high-contrast images, but with flat shadows and less relief.

gamma A measure of the contrast of an image, expressed as the steepness of the characteristic curve of an image.

gobo A corruption of "go between," this is anything used to block or partially block light.

gradation The smooth blending of one tone or color into another, or from transparent to colored in a tint. A graduated lens filter, for instance, might be dark on one side, fading to clear on the other.

grayscale An image containing pixels with brightness values only on a black-and-white scale with no color data.

GUI (Graphic User Interface) Screen display that uses icons and other graphic means to simplify using a computer. The Macintosh GUI was one of the reasons for Apple's original success in desktop computing.

haze The scattering of light by particles in the atmosphere, usually caused by fine dust, high humidity, or pollution. Haze makes a scene paler with distance, and softens the hard edges of sunlight.

HDRI (High Dynamic Range Imaging) A method of combining digital images taken at different exposures to draw detail from areas which would traditionally have been over or under exposed. This effect is typically achieved using a Photoshop plugin, and HDRI images can contain significantly more information than can be rendered on screen or even perceived by the human eye.

histogram A map of the distribution of tones in an image, arranged as a graph. The horizontal axis goes from the darkest tones to the lightest, while the vertical axis shows the number of pixels in that range.

hot shoe An accessory fitting found on most digital and film SLR cameras and some high-end compact models, normally used

to control an external flash unit. Depending on the model of camera, pass information to lighting attachments via the metal contacts of the shoe.

HSB (Hue, Saturation, Brightness) The three dimensions of color, and the standard color model used to adjust color in many image-editing applications.

hue The pure color defined by position on the color spectrum; what is generally meant by "color" in lay terms.

ICC profile A measure of a digital imaging device's color characteristics, used for accurate communication of color between devices, as set by the International Color Consortium.

interpolation Bitmapping procedure used in resizing an image to maintain resolution. When the number of pixels is increased, interpolation fills in the gaps by comparing the values of adjacent pixels.

ISO An international standard rating for film speed, with the film getting faster as the rating increases. ISO 400 film is twice as fast as ISO 200, and will produce a correct exposure with less light and/or a shorter exposure. However, higher-speed film tends to produce more grain in the exposure, too.

JPEG (Joint Photographic Experts Group) Pronounced "jay-peg," a system for compressing images, developed as an industry standard by the International Standards Organization.

layer In image-editing, one level of an image file, separate from the rest, allowing different elements to be edited separately.

LCD (Liquid Crystal Display) Flat screen display used in digital cameras and some monitors. A liquid-crystal solution held between two clear polarizing sheets is subject to an electrical current, which alters the alignment of the crystals so that they either pass or block the light.

light pipe A clear plastic material that transmits light, like a prism or optical fiber.

light tent A tent-like structure, varying in size and material, used to diffuse light over a wider area for close-up shots.

LCD (Liquid Crystal Display) Flat screen display used in digital cameras and some monitors. A liquid-crystal solution held between two clear polarizing sheets is subject to an electrical current, which alters the alignment of the crystals so that they either pass or block the light.

lossless Type of image compression in which no information is lost, and so most effective in images that have consistent areas of color and tone. For this reason, not so useful with a typical photograph.

lossy A file format which discards image information to create a smaller output file. Opposite of lossless.

lumens A measure of the light emitted by a lightsource, derived from candela.

luminosity The brightness of a color, independent of the hue or saturation.

lux A scale for measuring illumination, derived from lumens. It is defined as one lumen per square meter, or the amount of light falling from a light source of one candela one meter from the subject.

macro A type of lens capable of close-up photography at more than 1:1 magnification.

mask A grayscale template that hides part of an image. One of the most important tools in editing an image, it is used to make changes to a limited area. A mask is created by using one of the several selection tools in an image-editing program; these isolate a picture element from its surroundings, and this selection can then be moved or altered independently.

midtone The parts of an image that are approximately average in tone, falling midway between the highlights and shadows.

modeling light A small light built into studio flash units which remains on continuously. It can be used to position the flash, approximating the light that will be cast by the flash.

monobloc An all-in-one flash unit with the controls and power supply built-in. Monoblocs can be synchronized together to create more elaborate lighting setups.

neutral density Uniform density across the visible wavelength and of no color.

noise Random pattern of small spots on a digital image that are generally unwanted, caused by non-image-forming electrical signals.

open flash The technique of leaving the shutter open and triggering the flash one or more times, perhaps from different positions in the scene.

peripheral An additional hardware device connected to and operated by the computer, such as a drive or printer.

pixel (PICture ELement) The smallest units of a digital image, pixels are the square screen dots that make up a bitmapped picture. Each pixel carries a specific tone and color.

photoflood bulb A special tungsten light, usually in a reflective dish, which produces an especially bright (and, if suitably coated, white) light. The bulbs have a limited lifetime.

plugin In image-editing, software produced by a third party, intended to supplement a program's features or performance.

power pack The separate unit in flash lighting systems (other than monoblocks) which provides power to the lights.

ppi (pixels-per-inch) A measure of resolution for a bitmap image.

processor A silicon chip containing millions of micro-switches, designed for performing specific functions in a computer or digital camera.

Raw files A digital image format, known sometimes as the "digital negative," which

preserves higher levels of color depth than traditional 8 bits per channel images. The image can then be adjusted in software—potentially by three stops—without loss of quality. The file also stores camera data including meter readings, aperture settings and more. In fact each camera model creates its own kind of Raw file, though leading models are supported by software like Adobe Photoshop.

resolution The level of detail in a digital image, measured in pixels (e.g. 1,024 by 768 pixels), or dots-per-inch (in a half-tone image, e.g. 1200 dpi).

RGB (Red, Green, Blue) The primary colors of the additive model, used in monitors and image-editing programs.

saturation The purity of a color, going from the lightest tint to the deepest, most saturated tone.

scrim A light open-weave fabric, used to cover softboxes.

selection In image-editing, a part of an on-screen image that is chosen and defined by a border in preparation for manipulation or movement.

shadows The darkest tones of an image.

shutter speed The time the shutter (or electronic switch) leaves the CCD or film open to light during an exposure.

SLR (Single Lens Reflex) A camera that transmits the same image via a mirror to the film and viewfinder, ensuring that you get exactly what you see in terms of focus and composition.

split tone The addition of one or more tones to a monochrome image.

stop *see* f-stop. Also used as the action of closing the aperture, as in "to stop down."

TIFF (Tagged Image File Format) A file format for bitmapped images. It supports CMYK, RGB and grayscale files with alpha channels, and lab, indexed-color, and it can use LZW lossless compression. It is now the most widely used standard for good-resolution digital photographic images.

USB (Universal Serial Bus) In recent years this has become the standard interface for attaching devices to the computer, from mice and keyboards to printers and cameras. It allows "hot-swapping," in that devices can be plugged and unplugged while the computer is still switched on.

unsharp mask A process which increases the apparent detail of an image by computer manipulation.

white balance A digital camera control used to balance exposure and color settings for artificial lighting types.

Index

Bibliography & Useful Addresses

Books

The Complete Guide to Light and Lighting in Digital Photography
Michael Freeman

The Photoshop Pro Photography Handbook
Chris Weston

Perfect Exposure
Michael Freeman

Mastering High Dynamic Range Photography
Michael Freeman

Pro Photographer's D-SLR Handbook
Michael Freeman

The Complete Guide to Black & White Digital Photography
Michael Freeman

The Complete Guide to Night & Lowlight Photography
Michael Freeman

The Art of Printing Photos on Your Epson Printer
Michael Freeman & John Beardsworth

Advanced Digital Black & White Photography
John Beardsworth

The Photographer's Eye
Michael Freeman

The Photographer's Mind
Michael Freeman

The Photographer's Vision
Michael Freeman

The Photographer's Story
Michael Freeman

Websites

Note that website addresses may often change, and sites appear and disappear with alarming regularity. Use a search engine to help find new arrivals.

Photoshop sites
Absolute Cross Tutorials
www.absolutecross.com

Laurie McCanna's Photoshop Tips
www.mccannas.com

Planet Photoshop
www.planetphotoshop.com

Photoshop Today
www.designertoday.com

ePHOTOzine
www.ephotozine.com

Digital imaging and photography sites
Creativepro
www.creativepro.com

Digital Photography
www.digital-photography.org

Digital Photography Review
www.dpreview.com

Short Courses
www.shortcourses.com

Software
Alien Skin
www.alienskin.com

ddisoftware
www.ddisoftware.com

DxO
www.dxo.com

FDRTools
www.fdrtools.com

Photoshop, Photoshop Elements
www.adobe.com

PaintShop Photo Pro
www.corel.com

Photomatix Pro
www.hdrsoft.com

Toast Titanium
www.roxio.com

Useful Addresses

Adobe www.adobe.com

Apple Computer www.apple.com

BumbleJax www.bumblejax.com

Canon www.canon.com

Capture One Pro
www.phaseone.com/en/Software/

Capture-One-Pro-6 Corel
www.corel.com

Epson www.epson.com

Expression Media
www.phaseone.com/expressionmedia2

Extensis www.extensis.com

Fujifilm www.fujifilm.com

Hasselblad www.hasselblad.se

Hewlett-Packard www.hp.com

Iomega www.iomega.com

Kodak www.kodak.com

LaCie www.lacie.com

Lightroom www.adobe.com

Microsoft www.microsoft.com

Nikon www.nikon.com

Olympus www.olympusamerica.com

Pantone www.pantone.com

Philips www.philips.com

Photo Mechanic www.camerabits.com

PhotoZoom www.benvista.com

Polaroid www.polaroid.com

Ricoh www.ricoh-europe.com

Samsung www.samsung.com

Sanyo www.sanyo.co.jp

Sony www.sony.com

Symantec www.symantec.com

Wacom www.wacom.com